PHOTOGRAPHING
YOUR CHILDREN

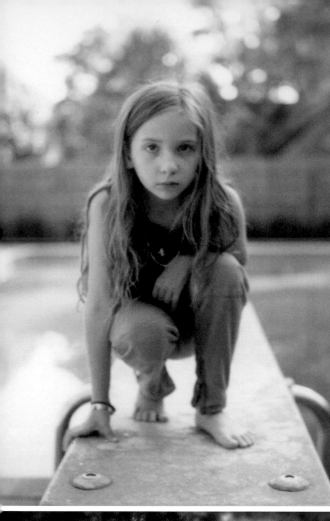

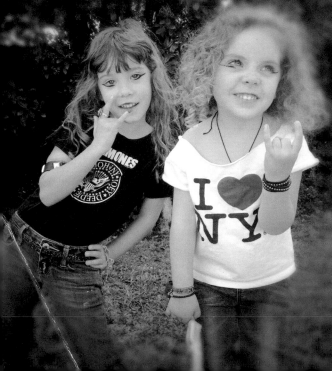

PHOTOGRAPHING YOUR CHILDREN

A HANDBOOK OF STYLE AND INSTRUCTION/**BY JEN ALTMAN**

CHRONICLE BOOKS

SAN FRANCISCO

Library of Congress Cataloging-in-Publication Data available.

ISBN: 978-1-4521-1057-8

Manufactured in China.
Page 149 constitutes a continuation of the copyright page.
Design by Lauren Michelle Smith
10 9 8 7 6 5 4 3 2 1

Chronicle Books LLC
680 Second Street
San Francisco, CA 94107
www.chroniclebooks.com

ACKNOWLEDGMENTS

Thank you to the wonderful parents who allowed me to photograph their beautiful children. They were such a joy to work with, and I'm honored that you allowed them to be a part of this project.

Thank you to my friends and fellow photographers for the work they contributed to this title—I admire what you do so much and am grateful for your time and energy.

Thank you to Amy Haney for her lovely color wheel and f-stop illustrations.

Thank you to Lauren for the beautiful and innovative design of this book.

Thank you to my wonderful editor and friend Bridget Watson Payne.

Thank you to my own parents for the beautiful photographs of my own youth; I treasure them.

Thank you to my husband for so many things, but greatest among them, our lovely daughters.

And thank you to my daughters, whose patience with me and my cameras seems limitless.

CONTENTS

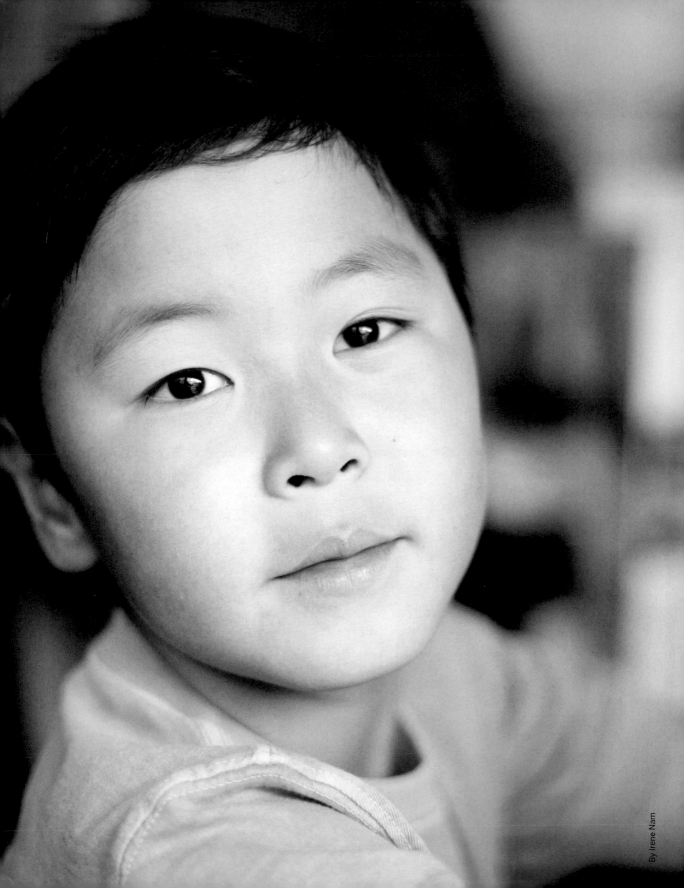

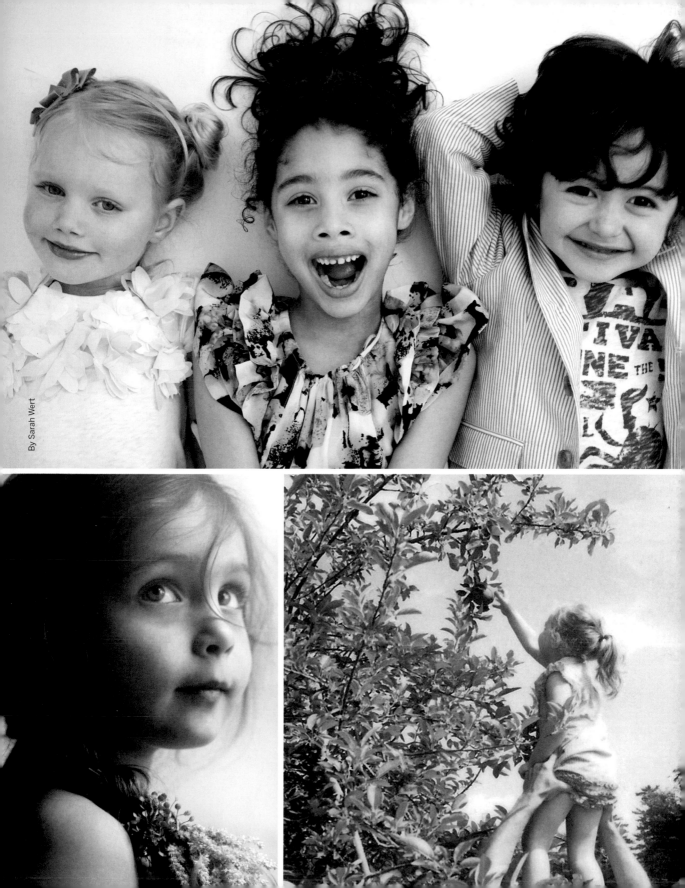

By Sarah Wert

INTRODUCTION

INTRODUCTION

Imogen Cunningham, one of the godmothers of modern photography, was once asked which of the many photographs she had taken was her favorite. Her answer was simple, "The one I am going to take tomorrow." This wisdom is nowhere truer than when it comes to photographing our own children. As they grow, we try to document each moment, in the hope that we can capture not only their fleeting changes, but their essential natures as well. Parents are notoriously busy, however, and all too often find themselves snapping photographs hurriedly, without much regard for anything but pushing the button and insisting that the child smile beaming back at the camera. The result is not only a lackluster experience for both parent and child, but also an image neither is satisfied with—we often sense a lack of reality in those pictures and a greater need for authenticity. But how to achieve it?

I started photographing my own children for the same reasons most of us do—to create a visual record of their lives as they grow. But at some point between the need to shoot and the actual process of doing so, I found that I really, really loved it. That is when everything changed. I realized that not only was I documenting their lives, but also that my work—my photographs—were becoming a beautiful tribute to our everyday existence. I worked hard to master light and composition, and when I began to see the results of this work in my shots, I was truly moved. The alchemy of child, light, and composition coming together can create such beauty. And the pleasure is not only in the photograph itself; you should find joy in the process of taking the picture as well. It took some time for me to realize that my children don't always have to smile, they don't always have to look at me, they don't always have to be "camera ready."

When I started photographing my girls, I used an entry-level digital single-lens reflex (DSLR) camera. It was a great little workhorse, and I found it very easy to use because I let the camera dictate the settings. Shortly thereafter, I discovered old Polaroid cameras, and they became my greatest teacher when it came to capturing light and learning how to shoot under various conditions. It was shooting film that fostered the desire to have more control over my digital camera. A good friend spent an afternoon with me in her studio, showing me how to shoot manually. This was my true awakening as a photographer. We will spend some time in this book discussing shooting this way and why it makes such a difference in your work. If you have a DSLR, I want to teach you how to really use your camera—to switch off that automatic setting for good and shoot confidently in manual mode. I hope that once you do, once you see what you yourself, and not just your camera, are capable of, you will fall in love with this process as much as I have.

This book will focus not only on the fundamentals of taking successful photographs, but it will also encourage you to challenge the preconceived notions of what children's photography should look like. I want to inspire you to photograph your own children in ways that you will regard as fine art, real and tangible. I want to help you make memories that are not saccharine, but rooted in the authenticity of the everyday. I will also ask you to rethink the idea of portraiture. There has been a popular movement in the last few years away from formal portraits, toward a more casual, in-the-moment, type of photography. Many of us spent too many painful hours in our own youth squirming in stiff clothes at the Sears Portrait Studio. And, consciously or not, we call upon those memories when we visualize how our own children's portraits might look. But the contemporary idea of portraiture has changed, to a more faithful representation of the child's own unique personality (without the Technicolor backdrop).

To grow as an artist and as a photographer, it is valuable not only to push yourself within the technical limits of your equipment, but also to study the work of both peers and professionals. Much great talent can be found in some of the children's photography groups on photo sharing sites like Flickr. It may be helpful to see the ways others are shooting and then question or critique that work. Ask yourself why you are drawn to a particular shot. Is it the use of light? The composition? Also look at images by the professionals. Seek out work not only by the masters of photography, but by painters as well. By studying fine art photography and painting you will begin to learn how these artists used light to highlight their subjects, bathing them in ethereal beauty. It may not be apparent at first, but all of this is part of the process of creating a personal style in your work. This will not happen overnight or within weeks. It takes time to cultivate a personal style, and the more

you learn about the way you love to shoot, the more you will begin to see your own style emerge. It cannot be forced. Nor can it be simply a reproduction of your favorite photographers' work. Rather, it will be a reflection of the intimate bond between you and your child, the magic that sparks between the two of you, captured when you press the shutter. Be open to change, to growth, and to embracing the organic nature of the process. And as you develop your own style of shooting, it's important to remember to always shoot for yourself and your child. Grandparents or friends may not understand what you're doing, but they don't have to. As long as you are shooting authentically from your heart, rest assured you are doing the right thing.

I hope to help you find yourself as a photographer in the pages of this book—that you will be inspired to take the next step and shoot creatively and with passion, and in doing so you will engage with your child on a deeper level. The intimacy you conjure during this learning process— as long as you practice with patience—will only strengthen the bonds between you and your child. And, although this is a book about photography, do remember that no photograph can take the place of truly living the moment. Which is to say: You don't have to photograph every minute of your son's birthday party. It is more important to your life, and to your little one, that you embrace some special moments *without* the need to record. But don't worry, you will learn to find this balance. And in doing so you can cultivate the greatest gift a photographer, or parent, can possess: patience.

CH. 1

THE BASICS OF PHOTOGRAPHY

One of the greatest gifts you can give your child as a parent is a visual record of their childhood. Photography is just that—a visual record—but it's also an art form, and it gives you an opportunity to instill warmth, emotion, realism, and even a touch of whimsy in the images that you capture. Utilizing a knowledge base about light, composition, balance, and unity, photographers have the ability to create visually arresting images that have continuing influence on the world. While technical advances have continued to push the medium forward, the social significance of photography has remained true to its origins. By documenting the social and cultural shaping of modern centuries, photography has become a historical gauge of sorts. It binds us to events, places, and our family, and it will continue to do so.

Whether you are new to the medium of photography or have been shooting for some time, this chapter will guide you through the basics that will best serve your needs as you photograph your child. With the digital age seemingly on fast forward, it can be difficult to keep up with the advances in digital photography. After a quick historical survey, I will break down the basics so that you know what type of camera is the best choice for your experience, potential growth, and lifestyle, and I'll give you some ideas about how to best use your equipment. This chapter will also touch on the resurgence of film photography and encourage you to explore fun alternatives to digital cameras, such as toy cameras and instant photography.

A WHIRLWIND INTRODUCTION TO THE
HISTORY OF PHOTOGRAPHY

The invention of photography shifted early perceptions of realism and helped shape the way in which we see the world. By forever recording reality as it was perceived, photography changed not only science and industry, but art as well. In a sense, art and science worked in tandem to further the early technology of photography, just as they do today. The rapid development of photography and its spread throughout the world is directly attributable to the desire for more affordable life-like representations. As artists began to experiment with photography and the cost of producing images fell, even those who could not afford to commission painters could acquire photographs, allowing photography to become a documentary tool as well. Starting in the mid-nineteenth century when Alexander Wolcott opened the first commercial portrait studio, and continuing through the later part of the century, the photographic portrait became a popular way to capture the human expression. Middle- and upper-class families flocked to newly established studios to create keepsakes that could be displayed in their homes as not only art, but as documentation of space and time.

In the modern era, two men, George Eastman and Dr. Edwin Land, pushed the boundaries of photography. In 1888, Eastman invented the first Kodak, a camera that held one hundred exposures within the confines of a small black box. Once the photographer had exhausted every exposure, the entire camera was sent to Eastman's processing facility in New York, where the film was developed, prints were made, and the camera was reloaded for its next use. In 1948, Dr. Edwin Land released the Land Model 95. It was the first instant camera—producing an image on paper just moments after the shutter button was depressed. Land continued to develop this technology into the 1970s and early 1980s, releasing the SX-70, the first instant single-lens reflex (SLR) camera. These developments changed the way people took photographs. It made photography a highly profitable industry and made accessible a medium that had been confined to the darkroom.

Through all the advances in photography into the twenty-first century, people continue to decorate their homes, and themselves, with photographs of family and friends. Beginning in the Victorian era with the inspiration of lockets containing photographs, creative jewelry designers continue to find new ways to set photos into their work, and such jewelry is an ever growing market. The reason is simple; human interaction—memories, holding onto keepsakes of those we love—doesn't change with technology. The desire for visual reminders is an eternal condition of the human soul. While the ways photographs are taken and shared has indeed changed over time (sending images

via e-mail or over our phones and uploading to photo-sharing sites like Instagram are the most recent methods), the desire remains. And like those before you, you are now setting upon a path to capture and share the everyday moments of your own family.

THE CAMERAS

Now that you know the way the medium has evolved, it's time to focus on the equipment. The camera is your essential tool in photography. While the camera itself plays a critical role in how you take pictures, honing your artistic eye is of equal, and perhaps greater, importance. We will discuss this in detail in the coming chapters. First, you need to identify the camera that best serves your needs. In the world of digital photography, four types of cameras normally fall into this category, and each possesses its own pros and cons. The four types are: medium format, 35mm digital single-lens reflex (DSLR), point and shoot, and device (the camera in your phone, for example). Medium format digital cameras are used primarily by commercial and editorial photographers, and the systems themselves can cost as much as a luxury car. These are likely to be out of reach of the amateur photographer, and will not be considered here. A lot of passionate photographers do not simply rely on one of the other three types, but use the benefits of each based on the circumstances. For example, point and shoots are much lighter and more compact than DSLRs and may be the best choice when you need to travel light. The selection available to consumers is overwhelming and often intimidating. But if you know what you want and need out of a camera before you start shopping, you are already ahead of the game. Understanding each system will help you make the best choice for yourself and for the way you and your family live.

DIGITAL SINGLE-LENS REFLEX CAMERAS

The digital single-lens reflex (DSLR) camera is the digital incarnation of the original single-lens reflex (SLR) film camera. Early camera models were essentially all built the same way. The film was located just behind the lens so that it could be properly exposed when the shutter opened. The viewfinder was set above or to the side of the shutter and lens. This meant that when you looked through the camera, you were not seeing exactly what would be captured on your film. Inserting mirrors into the body of the camera to redirect light to a ground glass, made it possible for the photographer to see through the viewfinder exactly what the camera's lens was seeing. The SLR was born. This mirror technology is still used in even the most advanced digital systems today.

TECHNOLOGICALLY SPEAKING . . .

Like the SLR film cameras before them, DSLRs are more expensive than point and shoot cameras, and for good reason—they produce the best images. However, many user-friendly and affordable models have appeared on the market over the last few years. What really sets DSLRs apart from point and shoot cameras is the ability to interchange lenses, which gives the photographer much more control over the final image. There is an adage in photography that it's not about the camera, it's about the glass (the lens), meaning that your camera is only as good as your lens. I belong to this school of thought: the better the lens, the better your final image. (We will go into this in detail later in this chapter.) A common misconception is that megapixels (Mpx) are solely responsible for overall image quality. In truth, Mpx is only one consideration. Megapixels are, in the simplest terms, small units that make up an entire image. The more Mpx a camera has, the higher the resolution of the final image—and the higher the resolution, the larger the final print can be. But there are two additional critical factors in image quality, the camera's sensor (the part that transfers light to image) and the lens you are using. DSLRs have larger sensors than point and shoot cameras, and as a result, fewer Mpx in these models will result in better images than more Mpx in a point and shoot camera.

WHEN A DSLR IS THE RIGHT CHOICE . . .

So why might this camera work for you? Let's take a look at the pros and cons of the system. For someone brand new to photography, there is a lot to learn with DSLR systems. With patience and practice, however, mastery is within your reach. The quality of your images, from both a technical and aesthetic standpoint, will be your reward. The beautiful depth of field (which areas of your photograph are sharp and which are blurred) and control you have with this system simply cannot be replicated with a point and shoot camera. The initial investment in a DSLR system should include a camera body and lens. Several manufactures offer entry-level DSLRs in packages that include both the body and lens (sometimes two lenses) together. This is a cost-effective way to familiarize yourself with this type of camera. Often, though, the lenses are not the highest quality glass. To have more control, my recommendation is to purchase the body and the lenses separately. If this is your first experience with purchasing a DSLR, it is important to visit a local camera store and actually hold the camera—feel how heavy it is and how much heavier with a lens attached. Reflect on how you live and whether you are willing to tote it around with you, or is the additional weight negligible compared to what you normally carry daily? I do not mean to imply that these cameras are all bricks, but it's important to consider your lifestyle—you do not want to spend a lot of money on a great DSLR system only to have it sit at home because you don't feel like carrying it.

Or maybe you plan on using it at home when photographing your child and carrying something lighter with you when you venture out? A good salesperson in a camera shop will allow you to slide the camera into your bag for a moment to let you feel the weight. The merchant can also be incredibly helpful in showing you the basic operating skills required for each system so that you can get started at home. To get the most out of your camera, however, it is very important to read your manual!

The most popular brands of DSLRs in terms of availability and model selection are Canon, Nikon, Pentax, and Sony. Other good brands are Leica, Sigma, Olympia, and Panasonic. One reason to choose a model from Canon or Nikon is lens availability. My personal belief is that you don't need an arsenal of lenses—a few will get any job you require done with ease. However, lenses are another factor to consider in your ultimate brand choice, as most are not interchangeable. Beyond lens availability, the choice of one brand over another is highly personal, and this is another reason to spend some time in a camera shop. Look at all of the available models in your budget. Which feels the most comfortable in your hands? Which camera's settings seem the most user-friendly? Once you've decided on a camera body, it's time to select your lenses.

LENSES

Lenses are the most important accessory you will purchase for your camera body. They come in an array of sizes and corresponding price ranges, some that might make you balk. I encourage you to spend some time researching your chosen brand of lenses. I have made the initial mistake myself on more than one occasion to save money and go with a lesser quality lens. It showed in my work immediately, and I then had to deal with the aftermath of selling the lens at a loss and purchasing the better lens. That is not to say that you have to buy the three most expensive lenses in a brand's line to be a successful photographer—not at all! It is more important to have one incredibly well-made lens than multiple lesser quality lenses. Camera lenses are differentiated by focal length and aperture. The focal length determines your field of view. A lens with a small number such as 14mm or 24mm (wide lens) will grant a rather wide field of view as shown in figure 1. A lens with a focal length of 80mm or 110mm will give you a narrower field of view (figure 2). So what is the difference in simple terms? If you are photographing the interior of a home or a landscape, for example, you likely will want to capture the whole room or as much of the horizon line as possible. In this case, a wide lens is ideal. However, if you plan on taking portraits, you probably want to focus on your child's face and the immediate surroundings, and a 50mm, 80mm, or 90mm lens is the best choice.

What makes some lenses more expensive is the second element, aperture. The aperture is noted as an f-number on the lens. The numbers can be confusing for beginners, because lower numbers indicate "larger" apertures. (I'll clarify this later in the chapter.) A lower number, f/1.8 or f/2.8, for example, will give you more control of your depth of field. In addition, you should note that the lower the f-number, the higher quality the glass and the more expensive the lens. In simplest terms, the depth of field determines what is in focus and what is not. Often, the most flattering portraits have a shallow depth of field (a low f-number/large aperture), the face is in focus and the background is almost hazy and dreamy. This can be achieved in-camera with a lens with a large (which means smaller number—it won't be confusing forever!) aperture. I say "in-camera" because some photographers achieve this effect with lower quality cameras in post-production software such as Photoshop; we will touch on post-production later in the book.

So what lens should you start with? Let's take a moment to look at your needs. You will probably find the most joy with the most versatile lens, one that allows you to capture close-up portraits of your child in their environment. I believe your best investment is a 50mm prime lens (also called fixed, meaning it cannot zoom) with an f-number of either f/1.4 or f/1.8. Your budget will be the

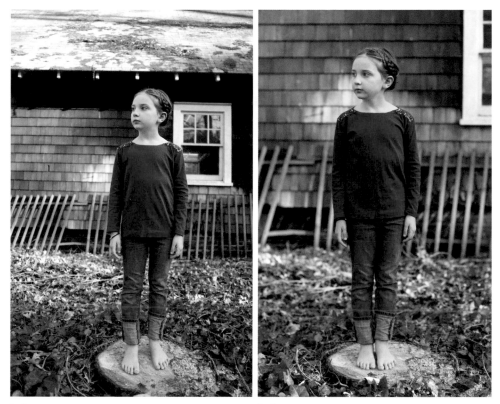

fig. 1 fig. 2

determining factor. The 50mm is highly versatile, and even if you begin to amass a collection of lenses, you may find yourself relying heavily on the 50mm (I do!). Prime lenses do not zoom, which means you have a little more work to do to capture the image you're after. However, it's widely held that fixed lenses are often of higher quality. If you think that a zoom lens is the only type that will fill your needs, try to find one with the lowest f-number and widest range of focal lengths. Photographers are passionate about lens choice, and most are very opinionated on the matter. While I swear by the 50mm for portraiture, another photographer may believe that nothing beats an 85mm. If you are wavering, many camera stores allow you to rent lenses by the day, week, and month so that you can test the lens before you buy. If you live in a smaller town, you can rent lenses from any of several excellent online rental companies. (You will find them listed in the Resources section.) When you are ready to expand your lens collection, I believe that a wide-angle lens between 24mm and 28mm and a macro lens at either 105mm or 110mm will meet all your needs. A zoom lens of 24mm to 70mm is another option. But try them out. Explore, push yourself, and have fun! Know that one amazing lens can change your photography life forever. I promise.

If you have decided to enter the world of DSLR photography, here is a quick list of what you need to get started (and what you can add later):

» **Camera Body.** Most bodies come with a camera strap, a battery charger, and one battery.

» **Lens.** Many lenses come with a lens bag and all should come with a lens cap.

» **Memory Card.** Your retailer can tell you which card will work in your cameras. Sizes from 1 gigabyte to 128 gigabytes of space are available. A 2 or 4 gigabyte card should serve your initial needs quite well.

Once you are comfortable shooting, you may want to add accessories to make your experience a bit easier in certain shooting situations. This list simply gives you an idea of the most popular accessories. You by no means need them to be an amazing photographer. Juergen Teller, one of the most sought-after fashion photographers working today, often uses cheap, disposable cameras!

» **External Flash.** If you do decide to shoot with the flash, an external one will give you much better control over where the light bounces and how it illuminates your subject.

» **Filters.** Filters serve a multitude of purposes from cutting glare to infusing color, and there are hundreds of them. It's best to shoot without one in the beginning to determine what your needs are in terms of this accessory.

» **Additional Batteries.** If you are shooting over several hours, at a family reunion, for example, it is helpful to have a back-up battery charged and ready to go.

» **A Battery Grip.** A grip that attaches to the camera and houses batteries to extend shooting time even further is another option. Fair warning: these grips add often unneeded weight to your camera.

» **Tripod.** If you want to try your hand at more formal portraiture or your available light is dim, a tripod can be a lifesaver. One of the primary causes of blurry pictures is camera shake; using a tripod avoids this mistake.

» **Light Meter.** DSLRs are equipped with internal light meters. However, in some circumstances, an external meter will serve you well. For example, If you are in a patch of sun and shooting your child in light shade, your camera will probably give you the wrong reading. You will get a better exposure if you use a light meter to determine the reading where the child is seated. A trick you can use if you don't have a light meter in this situation is to walk over to the child and meter your camera there for correct exposure. Then walk back to where you want to stand and shoot without adjusting your f-stop or shutter speed for the sun.

» **Remote Shutter.** This is a great tool for self-portraits and any time you want to appear with your child. The remote shutter syncs wirelessly with your camera to fire the shutter at a push of a button. The remote is also helpful in very low light situations when even pressing the shutter could cause enough shake to create unwanted blur in your image.

» **Camera Bag.** The more accessories you accumulate, the more important it is to have them all in one place.

» **Additional Lens** (discussed on page 24).

DIGITAL POINT AND SHOOT CAMERAS

Known for their light weight and ease of use, point and shoot cameras are the entry point for many people who want something to simply capture the important events in their lives. Point and shoots make up the majority of the digital cameras sold today, and the technology has advanced quickly so that high-quality models can be found for less than three hundred dollars. Point and shoots are just that. The camera will—and can—do everything for you. This is one of the reasons it is the most popular type of camera. Advanced models that have more functions and settings give you more control over your photograph. While you will not be able to achieve the range of depth that you can with a DSLR, you can still shoot beautiful photographs. New to the point and shoot market are hybrid cameras. Hybrids are still small and compact, but they have larger sensors and superior, interchangeable lenses. The hybrid is a great option for those who don't want to invest in a DSLR system.

TECHNOLOGICALLY SPEAKING . . .

If your main goal is to photograph your children, you should look for certain features and settings to be most successful. Remember megapixels? While more megapixels will give you a large image, it may not be a great image. What matters most, especially in point and shoots where you cannot change the lens, is the size of the image sensor. The larger the sensor, the better the quality of the image. This technology is constantly evolving in point and shoot models, so be sure to ask your salesperson which models have the largest sensors. Another important factor is optical image stabilization; this greatly reduces blur and can be quite handy if you are photographing children who are just learning to move and crawl—they are all over the place. In addition, select a model with a fairly high ISO setting. We will get into ISO in depth later, but in short, a higher ISO gives you more light, which gives you a faster shutter, which means less blur. Again, this feature makes photographing toddling little ones a bit easier. As with the DSLRs, you should do your research on specific brands and visit a camera store to test the controls and functions on several models. You are unlikely to find point and shoots available to rent like DSLRs, which is all the more reason to spend an afternoon in your local camera store.

WHEN A POINT AND SHOOT IS THE RIGHT CHOICE . . .

So why would you choose a point and shoot over a DSLR? There might be several reasons, including price point and ease of use. Again, I encourage you to look at the way you want to use the camera. Do you simply want something reliable that you can take on family vacations and snap photos of your children to share with friends and family? If so, a point and shoot with its automatic

settings and compact size is probably the right choice. If your decision hinges on price, you can still achieve gorgeous photographs with these cameras, and a little post-production can make them look like they were shot with a much higher end camera.

PHONE CAMERAS

As the demand for more streamlined and multifunctional electronic devices has increased, so has the quality of cameras found on these devices. None is more popular and easily used than the phone camera. There are many advantages to using phone cameras. Not only are you able to streamline what you're toting around, you can quickly share and even edit these images now. Countless user-friendly applications let you edit your photographs on the go, and some include their own built-in community (Instagram is one). Phone photography, or phonography, as it is sometimes called, is becoming an art form in itself. See the Resources section for some wonderful reads on this subject.

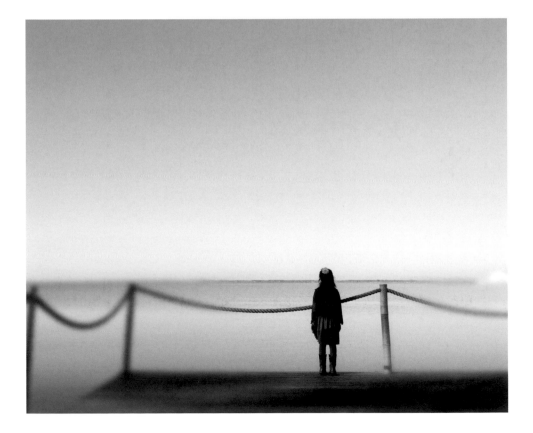

When Apple introduced the iPhone 4S, in 2011, it possessed an 8 megapixel camera coupled with the largest aperture available on a phone, allowing for better use in low-light situations. Users are able to shoot high-quality photographs that can be printed up to 8 inches by 10 inches and appear to have been photographed with a high-quality point and shoot camera. With demand on the rise, other companies are following Apple's lead and are creating phones with better cameras every year.

The primary advantage of a phone camera is sharing images on the go. What many have been calling "the new Flickr," Instagram allows you to take a photograph with your phone, edit it (allowing you to adjust focus and apply one of nearly twenty filters), upload it to a mobile site, and "like" and comment on other photographs—all within the platform. Through their own mobile site, you are able to link your Instagram account directly with your Facebook and Twitter feeds.

WHEN A CAMERA PHONE IS THE RIGHT CHOICE . . .

Everyone seems to love the phone camera for its portability, ease of use, and image sharing. Many professionals now use the phone camera to shoot quick tests for composition and light. Like everyone else, I love the fact that I can quickly, and beautifully, share photographs with friends and family while out and about. There are no cords, no memory cards, and no card readers needed— just you and your phone and instant sharing.

FILM, TOY, DISPOSABLE, AND INSTANT CAMERAS

Film photography is both wholly tangible and all at once magical. Whether or not you've stood in the pungent, rose-tinted light of a darkroom, there is a thoughtfulness and reverence to shooting with a film camera. If you are new to photography, I encourage you to seek out a film camera to play with. It by no means needs to be an expensive model. It can even be a "toy camera," but you will not have a better lesson on patience and light than what that camera can teach you. Each frame is its own little universe and should be respected as such; the more you shoot with a film camera and note the results once they've returned from the photo lab, the more your confidence as a photographer will grow. Ultimately, you will be that much more efficient at shooting digitally.

You can choose from any number of film cameras including the 35mm SLR (the forebearer of the DSLR), medium format cameras, and toy cameras, as well as instant cameras. A 35mm is a wonderful place to start to practice the basics, as we'll discuss shortly. You can hone your knowledge

of aperture and shutter speed with an older, fully-manual camera, or just experience the beauty of film with an automatic. Medium format cameras come in all sort of varieties, from the top-end Mamiya and Hasselblad professional models to the Twin Lens Reflex (TLR) cameras and even toy cameras such as Holga and Dianas.

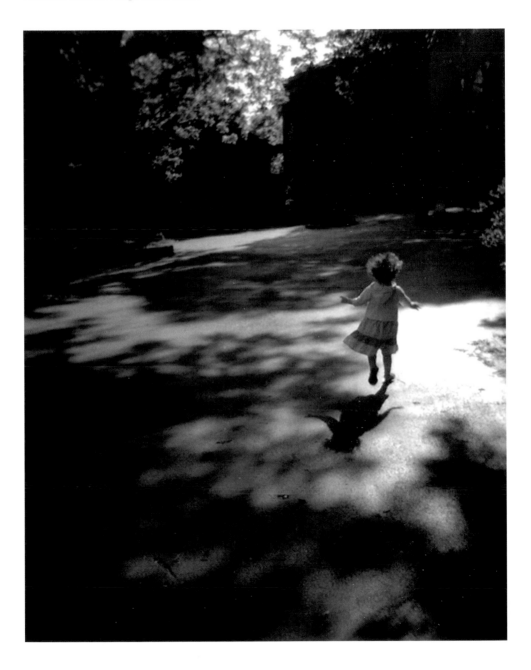

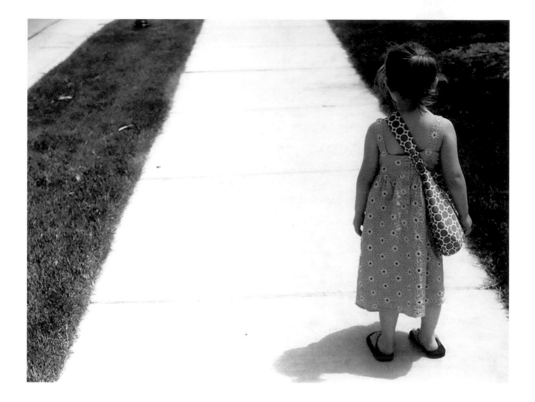

TLR cameras, shown in the image to the right, are nostalgic fun, and children find them especially fascinating. Instead of viewing your subject directly through the viewfinder in front of you, you look down into the viewfinder, which reflects the image back to you. Most of these cameras are fully manual, but some are equipped with light meters to help you set your aperture and shutter speed. They take medium format film and produce square images.

TLR cameras are also ideal for building TTV (through-the-viewfinder) cameras. A TTV is a twin reflex that has been fitted with a long box atop the viewfinder. Using a macro lens on a digital camera, you shoot through the box and viewfinder, which results in a digital image with a very nostalgic look. (Many fans of this technique have also been successful using the macro setting on point and shoot cameras.) This look is ultimately created by the small scratches and blemishes on the lens of the TLR you are shooting through. The best camera to use for this technique is the Kodak Duaflex, which is inexpensive and fairly easy to find on eBay. You will not be inserting any sort of film into the body of this camera, but do ensure that the listing for the camera you buy states that the viewfinder and lenses are fog free. Small scratches are okay, as they will add to the overall feel of the final photograph.

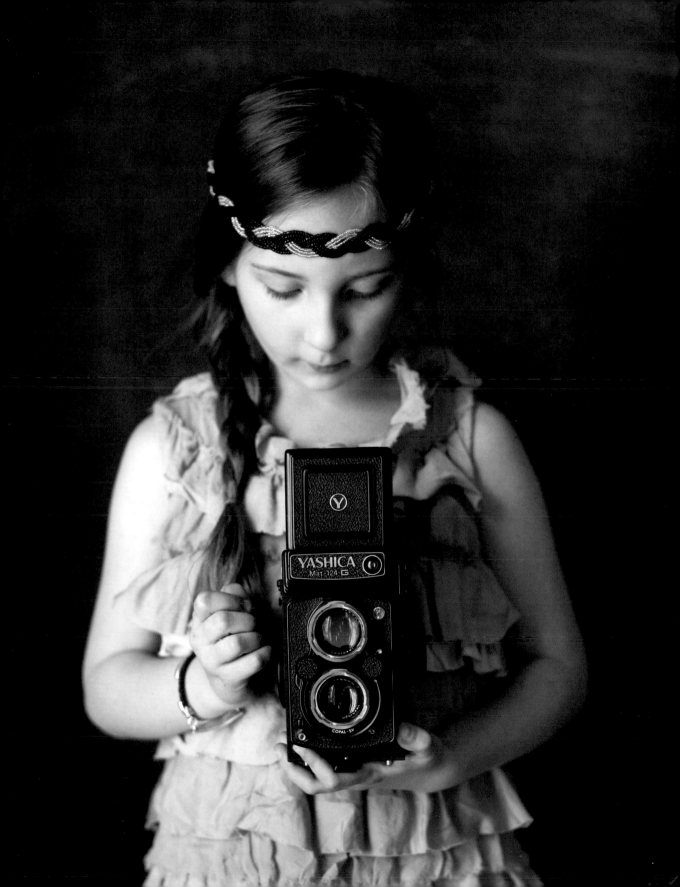

Another medium format option is the toy camera. The most popular brands on the market today are Holga and Diana. Both have simple, inexpensive, light-weight plastic bodies and lenses. Most are fully automatic and provide only a dial for adjustments for indoor and outdoor lighting. Because they are built so cheaply, they often produce light leaks, and this unpredictability is one of the reasons photographers are drawn to them. Some people use black tape to cover all the seams of the plastic housing to ensure that no light leaks penetrate to the film. Others, however, embrace the nuances of the camera. These cameras are also easy to use to create double exposures. Simply do not advance the film after you press the shutter and take the second exposure. When developed, the images produce an almost ghost-like effect.

By Jennifer Way

Instant cameras are near and dear to my own heart. They capture light like no other camera ever made. Though the Polaroid Corporation gave up the production of instant film in 2008, a new sun has risen in the hearts of instant photographers. The Impossible Project (TIP), a company based in the Netherlands, purchased the European Polaroid film production facility and essentially saved integral film. TIP now makes products for all Polaroid integral film cameras. Both TIP film in black and white and color is beginning to equal the quality of the original Polaroid films. The magic has been reborn.

Fuji also continues to make films for both older model Polaroid cameras that take peel-apart (or pack) film and their own creation, the Instax. Produced in a Mini and a Wide model, the Instax is all about point and shoot instant fun. Fully automatic, the camera is a great, inexpensive entry to instant photography, and it's even more fun when you put the camera in little hands (more on that soon!).

HOW TO SHOOT

Now that you have your camera, you are likely very eager to start using it. Though your manual may look slightly intimidating with too much technical jargon, you should read it before shooting. But before you read your manual, read this section of the chapter. Knowing some of the key terms used, what they mean to you, and how you shoot will make reading that seemingly boring manual more interesting and understandable. While I will not flat out tell you not to use the automatic settings—I want you to be comfortable—I will do everything in my power to convince you to try shooting manually. I cannot overstate the difference you will see in your images if you take the time to learn a few easy steps. Shooting manually is not as difficult as it used to be, because digital cameras are all equipped with internal light meters. The more informed you are about some rather simple settings, the more confident you will feel about shooting.

ABOUT F-STOPS

Regardless of brand name, most 35mm film and DSLRs operate the same way. When you shoot in A (or Automatic) the camera decides what f-stop and aperture your subject requires. But maybe you don't like what the camera does. Figure 3 is a photograph shot in A and then again shot in M (Manual). Do you see the difference? The colors in the second image are richer, the depth of field is stronger, and the overall light is more flattering.

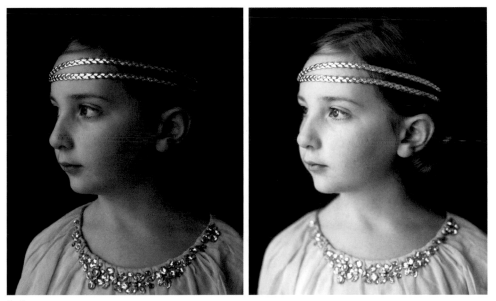

fig. 3

Let's start with what an f-stop actually is. (You may see this also referred to as f-number.) F-stop refers to the setting that dictates how much light is being allowed inside the camera. When you press the shutter button (to take a photograph), you are opening a hole that permits the sensor to see your subject and allows light into the camera. The f-stop controls tell the camera how large or small that hole will be. A smaller hole (or aperture), which is indicated by a higher f-stop number, will allow less light into the camera; while a larger hole/aperture (and smaller f-stop number) will let more light into the camera. Figure 4 shows how the aperture (hole) size corresponds to f-stop numbers. Refer to this chart as we continue the discussion.

fig. 4

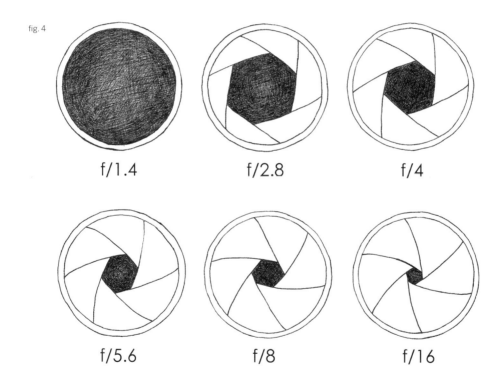

f/1.4 f/2.8 f/4

f/5.6 f/8 f/16

The f-stop is important for controlling not only the light, but also the depth of field. *Depth of field* describes which areas of the photograph are in focus and which are not. Of course, focus (or sharpness) is also controlled by what you allow your lens to focus on; but depth of field describes the entire photograph. In figure 5, the first photograph is shot with a large aperture—and remember that a large aperture means a smaller f-stop number. Do you notice that the subject's face is in focus (or sharp) but everything around her is out of focus (often called soft focus)? In the second

photograph, the background is as sharp as the girl's face. Which do you think is more appealing for a portrait? Keeping your subject's face as the primary focus is exceptionally flattering and much more aesthetically interesting. The viewer is not overwhelmed with everything else in the scene, and is drawn to just the quiet beauty of the child's face. The f-stop numbers are drastically different in these examples. Why does the light look the same? Let's move on to talk about shutter speed to find out.

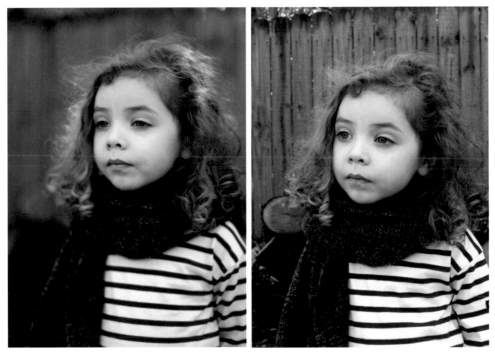

fig. 5

ABOUT SHUTTER SPEED

Remember that hole that opens and closes? The one that your f-stop controls dictate the size of? You can also control the speed with which it opens and shuts. The mechanics of the camera make that hole open every time you press the shutter, then close immediately once you've captured your image. A faster shutter speed means that the shutter will open and close quickly, letting little light in; a slower shutter speed means that the shutter stays open longer, allowing more light into the camera. Knowing how the shutter works, let's revisit the images in figure 5. If I shot the first image with a smaller f-stop (a large hole), did I need a quick or slow shutter speed to control the amount of the light entering the camera? A quick shutter speed, because that hole is already wide open,

letting lots of light in, right? For the second image, the larger f-stop (a small) hole would require a slower shutter speed to let as much light in as possible to ensure the correct exposure. One consideration about slower shutter speeds, however, is camera shake. The longer the shutter is open, the longer it's exposing your subject. If you even take a breath, you may end up moving the camera just enough while the shutter is open to create a bit of blur in your image. But there is a solution for that as well! You can put your camera on a tripod to ensure that it stays perfectly still, or you can change your ISO settings.

ABOUT ISO

The last consideration in proper exposure is the ISO. In film cameras, ISO refers to the speed of the film. Films with lower ISO numbers, like ISO 100, require more external light in order to be exposed correctly, while higher numbers, such as 800 and 1200, require less. Although digital cameras do not use film, they do still have ISO settings and operate the same way a film camera would. Instead of the light hitting the film, however, it's hitting the image sensor. ISO is another tool to help you control the light. If you are shooting on a bright, sunny day, you will find that setting your ISO low, at 100 or 200, for example, will give you plenty of light. If you are shooting in a darker room lit only by one small window, though, one option is to use a slower shutter speed to get enough light into the camera. But how do you avoid camera shake? Set your ISO number higher, allowing your f-stop, shutter speed, and ISO to work together to create a perfectly lit photograph. Something to be aware of, however, is that the higher the ISO number, the more "noise" you will see on the image. In film photography, this is called "grain" and can be very beautiful in black and white film images. However, digital grain, or noise, is not as attractive. Placing your camera on a tripod in low light situations, will allow you to balance your ISO with your shutter speed to avoid heavy noise.

USING THE LIGHT METER

Now that you know how to control the camera settings, you need to ensure that you and the camera are on the same page. On most DSLRs, when you look through the viewfinder on your camera and press the shutter button halfway, you see a little chart. It may be on the bottom of your screen or to one side depending on the model. This is your internal light meter.

The (+) numbers show how many f-stops overexposed the camera believes your image to be; while the (-) numbers show how many f-stops underexposed the camera is seeing. (Overexposure

results in a washed-out image, and underexposure in an image that is too dark.) As you shoot more, you will determine the best method for controlling your settings. Personally, I start by thinking about how much depth of field I want and set my f-stop accordingly. Based on that information, I am then able to set my shutter speed according to the light meter. In theory, your image will be perfectly exposed when the little dot or needle (depending on what your meter chart looks like) is right in the middle. However, because lighting situations vary widely, you cannot always believe what the meter is telling you, and this is why it is so important to play! (We'll talk more about lighting in the next chapter.)

MANUAL MODE ON POINT AND SHOOTS

Nearly all point and shoot cameras are equipped with manual settings and work somewhat the same as DSLRs. You do not have as much control over your depth of field, however. The sensors in these cameras are simply too small. Instead, you can use the f-stops to control how much light you are letting into the camera. Point and shoot cameras, especially when shooting in automatic mode, will likely fire the flash when you need more light. TURN THE FLASH OFF! You are now equipped with enough knowledge that you do not need to rely on a tool that will probably wash faces out and create unflattering shadows. If you need more light, try setting your ISO higher and your f-stop lower. As we have already discussed, these are the primary tools for allowing more light into the camera. This is also helpful when babies and little ones are on the move, as motion causes blur. Speeding up the shutter (i.e., using a higher ISO and a lower f-stop) will make it easier to capture your little one scoot across the floor. If you've really fallen in love with that soft focus achievable in DSLRs with a low f-stop, you can simulate this look in photo-editing software.

LETTING YOUR CAMERA HELP

Most DSLRs and point and shoots give you more options than just manual and automatic settings. Some allow you to set your f-stop, and then the camera automatically determines your shutter speed (and vice versa). However, keep in mind that sometimes the camera simply cannot read the lighting situation correctly, and your exposure still may not be what you had in mind. It is best to play with these settings and determine for yourself if you like the look of the final images.

In this chapter we have touched on the fundamentals of photography. There is much more to learn and explore on this subject, and I have provided a list of some of my favorite photography books in the Resources section of this book. Read as much as you desire, but remember that, ultimately,

the old adage that "practice makes perfect" holds exceptional truth in photography. With time, you will look at the scene before you and have a good idea of what your f-stop should be and where to set your ISO. Shooting manually, you will not only gain confidence in your skills, you will have much more control over your image and be able to spend more time shooting than editing your images on a computer.

And though I speak very highly of film and its wonderful capacity to teach you patience when shooting, there is something to be said about the ability to shoot more freely with a DSLR system. Film is expensive, and related processing takes time and money. When you are starting out, shooting digitally lets you see your mistakes immediately and correct them immediately. But do remember that if you feel your passion for photography flowing, explore everything, film included.

CH. **2**

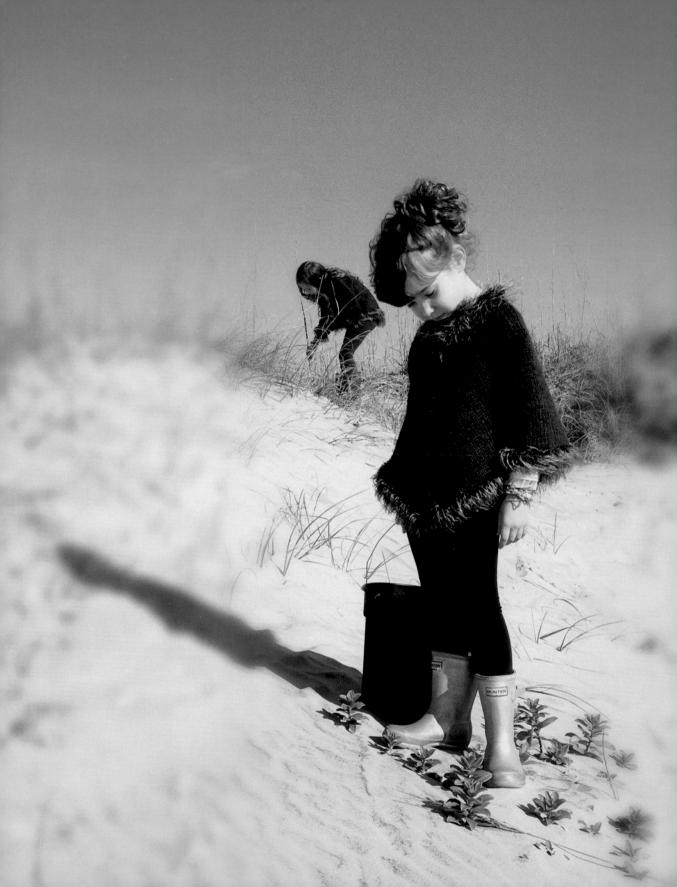

WHY LIGHT IS SO IMPORTANT

Light is where the magic sleeps. It is the most important element to consider when taking a photograph, and once you learn to really and truly *see* light, to make it bend to your wishes and desires, then you become a part of that magic—it makes you the magician. Light is used not only to illuminate your subject, but also as a compositional element. In this chapter, I will review the most common lighting situations and how to take advantage of them. We will look at the difference between natural light and interior light, and I'll offer guidance on how to hone your eye to read a lighting situation so that you can shoot with more confidence and, ultimately, more beautiful results.

OUTSIDE

Many people who photograph casually, shooting simply to record moments, may be surprised to learn that direct, midday sun is not your friend in terms of a flattering portrait. The idea seems obvious: more light on your subject equals a better photograph. That is a partial truth, as the type of light is as critical to success as the amount of light. Midday, or full sun can create harsh and unflattering shadows across the contours of your child's face. There is also little visual warmth to this type of light, and it often creates white spots or washes out your subject. Finally, it's not comfortable for your subject, especially a child. Your first reaction to harsh sunlight is to squint, so is a child's—but a child will also instinctively place her hands over her eyes or across her forehead to protect her eyes—probably not the look you were going for in your portrait. If you're on family vacation and feel the need to capture every moment, you can still achieve beautiful results at midday by finding some shade. Shaded areas during this time of day will vary. Find light shade,

preferably evenly shaded, and adjust your settings for the available light. The resulting photograph will be much more flattering, and your child should not be tempted to shield her face. The image in figure 6 was shot in full sun at midday. Notice the subtle shadows across his face. By exploring the angles you are shooting from, you can lessen the appearance of these shadows, but not eliminate them.

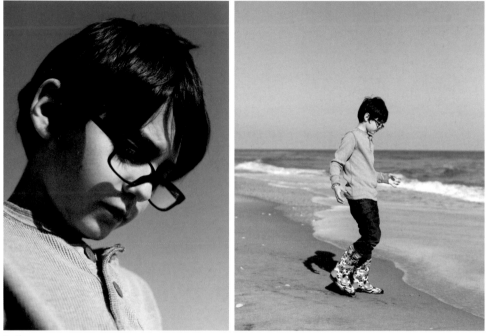

fig. 6

Dappled light (the sun coming through tree leaves, for example) is gorgeous, there's no question. But while it may be a beautiful compositional addition to a farm table overflowing with a summer feast, it's not necessarily ideal for portraits. Those little dots of light can create spots all over your child's face, so be mindful when shooting in these conditions. You can capture this type of light, but do ensure that your child's face is illuminated evenly.

The best time of day to photograph your child is in the morning or the evening. The light is much softer and more flattering to skin tones, and you will likely have more options in terms of where you place your child in that soft light than you do under a harsh sun. This type of light is commonly referred to as *the golden hour*, and when you see the beautiful tones in your images, you will know why.

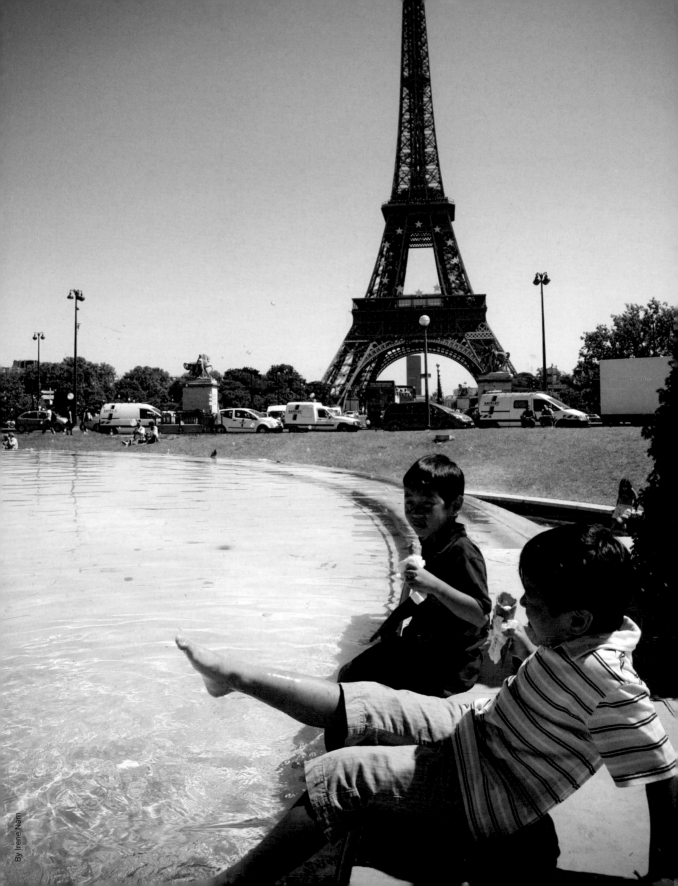

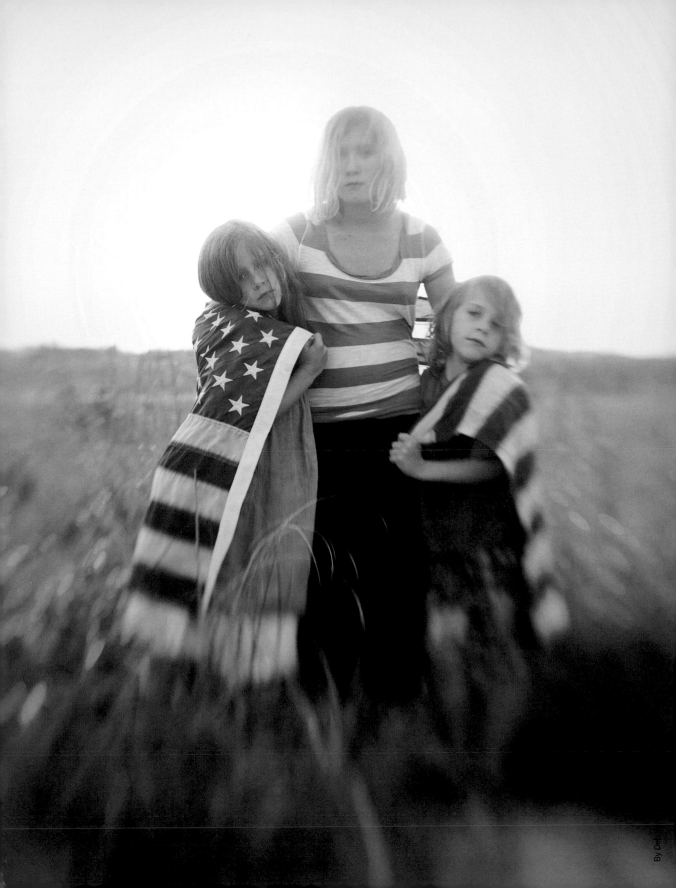

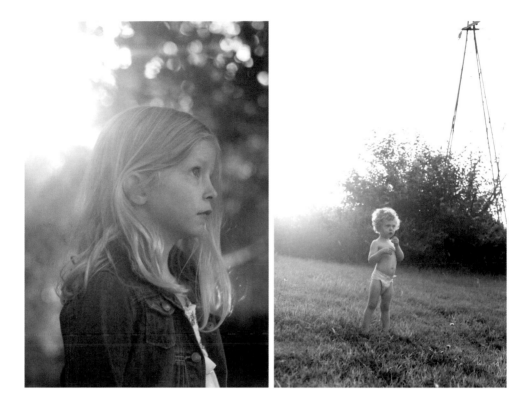

This is also the time to explore shooting into the light to create a bit of flare. Flare is the streaks or bubbles of light that appear on your image when a strong exterior light source (usually the sun) hits your lens directly. A lot has been written about how to avoid flare, but it can be a beautiful compositional tool as well. Flare can best be achieved in manual mode (so do it now!) and with a few considerations . . .

» Shoot into the light. You need to be proactive here and move yourself around a bit. You will know you are in the right position when you see the light burst open a little through your viewfinder. That's the time to shoot. This is one of those lighting situations where you and your camera will not see eye to eye. Your light meter is sure to tell you that your picture will be overexposed. But go ahead and shoot a few frames, and then adjust your shutter speed until your entire image is illuminated the way you want it to be.

» Ensure that there is still enough light on your child's face. If you are shooting into the light, then your subject's back is most likely facing the light source. You need to ensure that the sun is still high enough to adequately illuminate the child's face.

» Be aware of where your camera is focusing. If you are shooting on autofocus, the camera will be attracted to the light source. It's best to switch to manual to ensure that the focus remains on your child's face.

» Be mindful of the rings that flare can create on your image. They can look pretty cool, but if you'd rather not see them in print, take a step back to give yourself enough extra image space to crop them out later. You may also be able to eliminate or downplay the rings by moving the camera just a bit. Play with positioning until you capture what you are looking for.

Another lighting situation you are sure to encounter outside is cloud cover. Do not let this discourage you. Cloud cover gives you a soft, even light that can be beautiful in portraits. In harsh, midday, outdoor light, the sun can create unwelcome shadows across your child's face. Clouds are your biggest ally in creating beautifully—and evenly—lit portraits.

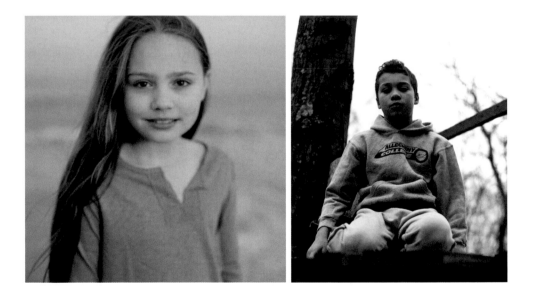

One more thing to consider. If you are shooting manually, you may notice a significant difference in coloring (K-temp), especially in skin tone, when you move from a full sunlight or indoor lighting situation to cloud cover. Sunlight tends to lend a yellow tint, while cloud cover can read blue. By adjusting your color temperatures in your DSLR's menu, you can easily correct for this. The laws of color theory apply here. If your images are too blue, add yellow; if your images are reading too

yellow, increase the blue. There will be specific instructions on how to access this menu in the instruction manual for your DSLR.

INSIDE

SUNLIGHT

Shooting inside does not necessarily mean no longer shooting with natural light. However, there are significant changes to consider when moving inside. Ideally, you want to seek out pools of natural light. But remember our discussion of harsh, midday light and skin-tone coloring? You will likely face these same issues indoors if your light is not diffused in some way. The simplest way to diffuse light is to move into a slightly shaded area, where the sun is not bright, but the room is still well lit. Your child will be more comfortable out of the heated pockets of sun, and you will have better results when you shoot. Another great way to diffuse light is with sheer curtains. Curtains allow you to make the most of your light source by shooting near the window (for example), while still being able to keep the light soft and flattering.

AMBIENT LIGHT

While the ideal is to always use natural light, you will likely find yourself in situations where this is just not possible. Several factors will affect your photography in this scenario, but all fall victim to the light source itself. One of the first considerations should be the placement of the light source. Just like the sun, light bulbs, whether overhead or tableside, can also create unwanted shadows. Second, the type of light bulb will affect the color cast, which is most noticeable on skin tones. Last, the brightness of the bulbs will be a factor in how you shoot.

Shooting indoors under ambient lighting may teach you rather quickly how important it is to learn to shoot manually. By setting your camera to manual, you will be able to use f-stop and shutter speed to control the amount of light entering the camera; you will also be able to adjust the K-temp. Most light bulbs tend to read yellow or orange in terms of skin tone in digital images. Add blue to achieve more natural results.

Try to keep your children away from overhead lighting and tableside lamps. You will find that, like the sun, these light sources create both shadows across the subject's face as well as "hot spots"

(areas that are completely white). Remember to use your ISO settings in this situation to achieve more light in the image without relying so heavily on your outside light source.

Another common way to deal with these situations is to post-process your photographs in black and white. I still recommend shooting in color for two reasons. The first is that you may have some color shots that work quite well, or can be easily color-corrected. Second, you will have more success editing color images into black and white, because the color tones are easier to manipulate than the gray tones of the black and white setting on your camera.

HOW TO FAKE A STUDIO

To create a studio lighting look in your images requires a bit of equipment, but by no means do you need to invest in full-scale studio lighting. If you are trying to achieve a studio look, first try to set your children up by a window using a sheer curtain as a filter. If your light source is coming from one direction, say one window, then you can also use something to "bounce" the light back onto the underexposed portion of your child's features.

For example, say you've set your daughter in a chair in a room with one large window. The window is to her right, and she is facing you and the camera. If you look carefully, you will notice that the left side of her face and body, the side facing away from the window, is significantly darker than the right side. You could turn her to face the light source. However, this is not always ideal because once you move in front of her to take the photograph, you may find that you are blocking a good portion of that light. The better option is called "bouncing." Placing a large, bright, white, flat surface on the left side of her will effectively bounce the light back into her form. You can purchase light bouncers (called lighting reflectors) and stands from large camera shops. But you can also purchase large white mat boards from craft stores and prop them up with stacks of books. You can wrap these mat boards in tin foil to get that light to really jump back into your frame. At first, the difference in light may not be noticeable to your naked eye, but you will see the difference on the display screen of your camera. You may have to move and tilt the board around a little, but the more you practice with bouncing, the more you will notice the subtle shifts in light as they fall across your child's form.

If you do not have enough natural light to work with, you can purchase a few types of lights that will help create a studio look. Studio lighting is soft and even. The best way to achieve this is, of

course, with a soft box (large diffusers) and a beauty light. However, these can be pricey additions to a makeshift home studio. Instead, try these tricks:

» Use a minimum of two light sources to avoid shadows and uneven lighting.

» Try using daylight bulbs, as they are softer than traditional light bulbs and will not affect skin tones as harshly.

» Purchase inexpensive workshop lights from your local home improvement store. They come both on stands and as portable units. The portable lights often come with a clip that allows you to secure them on a bookshelf or chair. Look for a light that will allow you to swivel the head to adjust where the light falls.

» Diffuse! Drape an ultra sheer cloth over the lights to soften the look. Just be mindful of two things here: first, that the bulbs are bright enough to illuminate your subject through the fabric, and second, that you NEVER leave the covered lights unattended because of the risk of fire.

» Regardless of the type of bulb, it's still a bulb, so be sure to adjust your color temperature accordingly.

» Set your child down before adjusting the lights. It is important to have the child in place so that you are able to adjust the light to fall most flatteringly across his face.

» Check the Resources section in the back of this book for websites dedicated to do-it-your-self photography. There are some great tutorials on building your own lighting kit.

The final consideration in setting up a quick home studio setting is background. If you have a blank white wall, that's a perfect start. I painted one of the walls in our kitchen nook with blackboard paint, and it's proved to be my favorite area in the house to shoot. If you have the ability, you can also hang a bar almost flush to the wall and ceiling over the area you plan to shoot in; this will allow you to hang different fabrics up for varying backdrops. Do not discount wallpapers, fabric, and even paint. Covering large mat boards or even old doors in these materials will give you a nice variety to choose from when you want to set up a shoot.

You can also take the studio outside. Pin or nail a sheet against your house, garage, or even between two trees, and you're good to go! Just be sure to adjust your K-temp settings for the change in light for the bounce the sheet or backdrop is likely to create.

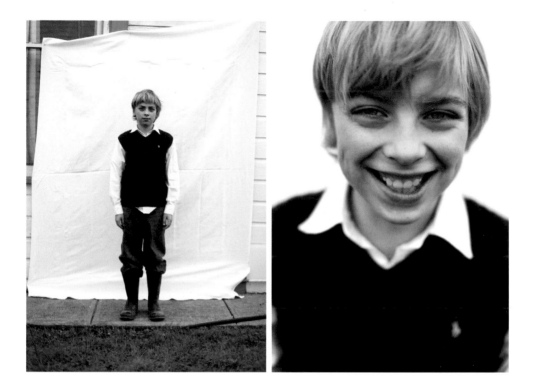

As we've discussed in this chapter, lighting is paramount to a successful photograph and never more so than in a portrait. As you continue to shoot and experiment with different lighting situations, you will find not only your knowledge base, but also your confidence, growing. You will know that you can shoot a beautiful photograph of your child under any circumstances—and what a wonderful power to possess.

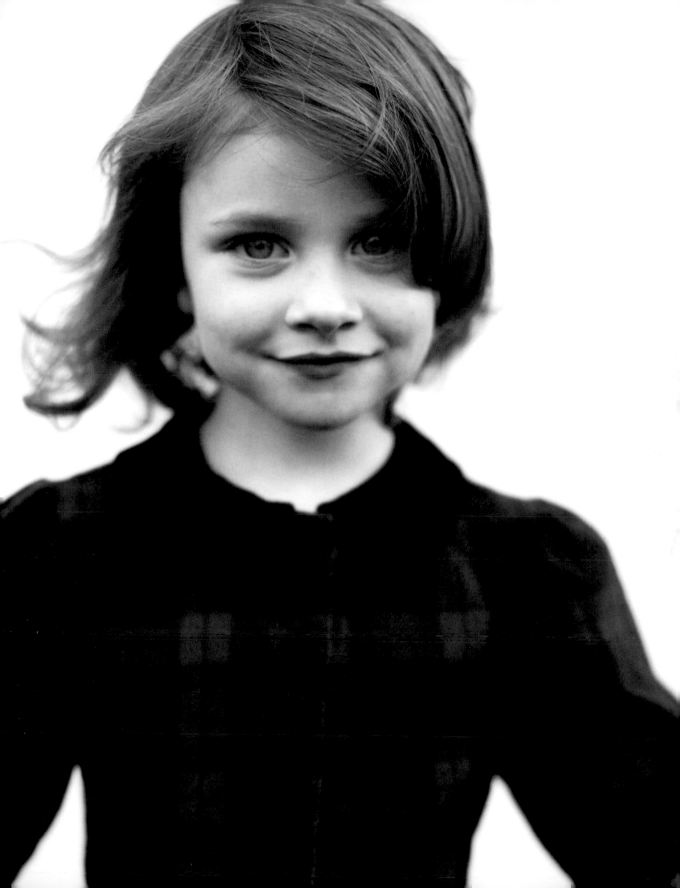

CH. **3**

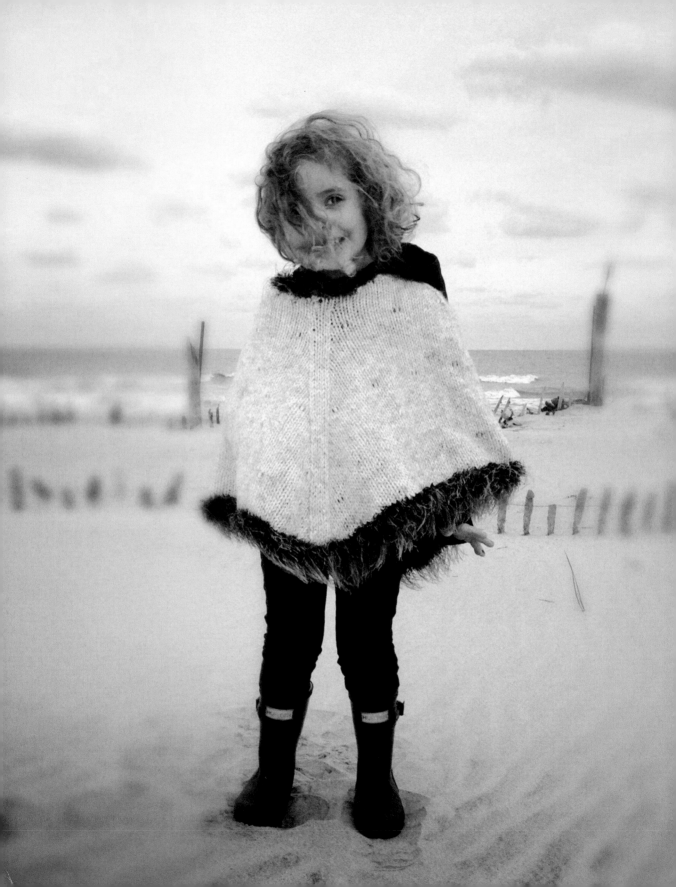

COMPOSING PORTRAITS

My greatest hope as you embark on this journey to photograph your children is that you find passion in what you are doing. When you begin to capture images that are true reflections of your children's natures, I know that you will begin to feel that excitement, and it will stimulate you to branch out creatively. In this chapter, we will discuss the basics of composition—how to compose beautiful portraits and what factors you should keep in mind to create aesthetically pleasing images. But we will also push that proverbial envelope a bit. We will discuss the difference between more candid and more consciously composed shots. As much as I want you to practice photographing your children in their natural environment and as spontaneously as possible, I would love for you to find equal joy in setting the scenes for your photographs. There is nothing false or contrived if you create settings that your children love being part of. As you let your imagination run with ideas, remember that if your children are enjoying themselves—if you are having fun—you're not just creating a more interesting composition and setting. The act of creating becomes a joyful moment in itself in your life together, not simply a stage. This is an important step in developing your own style as a photographer. It is something that will naturally evolve over time.

THE BASICS OF COMPOSITION

The rules of composition are universal across artistic mediums. But we should begin with what *composition* is. In a photograph or a painting, *composition* refers to the arrangement of objects or subjects within the image. Are the objects within the frame well balanced? Does your eye move throughout the image easily? Did the artist use color, texture, and shape to unify the image overall? All of these factor into the success of a composition. Let's begin with the most commonly used tools in portrait photography.

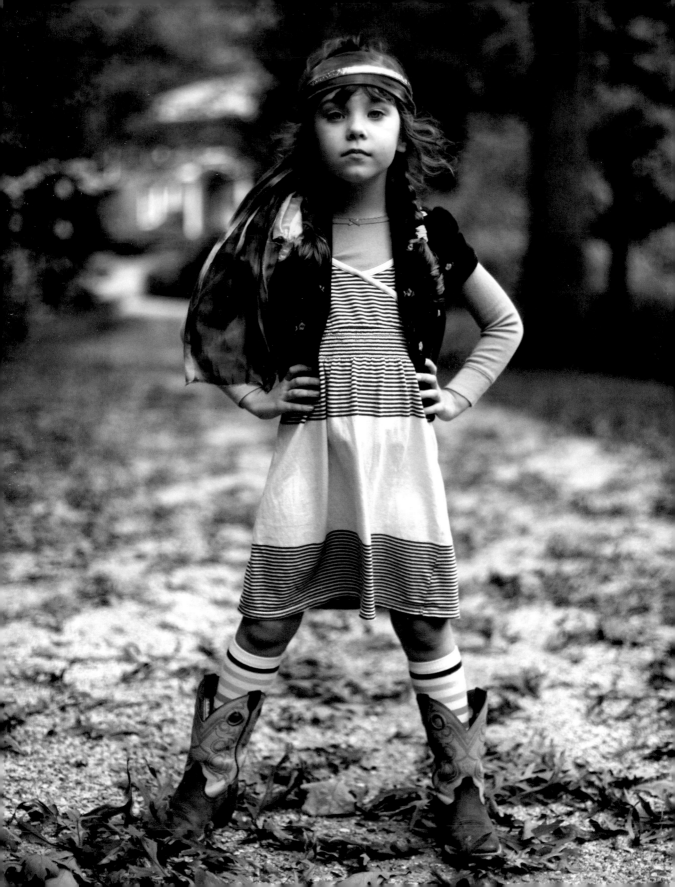

RULE OF THIRDS

The rule of thirds simply divides your composition into three equal sections both vertically and horizontally, as figure 7 illustrates. The idea is that placing your subject on one of those lines, as opposed to between them, produces a more interesting image. You will learn to see this grid in your mind's eye when you look through the viewfinder. After a while, you'll find that you naturally begin placing your subject on the imaginary lines. However, the entire subject, say your daughter, does not have to be fully aligned with that line. The focal point of your shot is likely her face, so make sure the focal point is what is intersecting the line. But what's more fun than following rules? Breaking them. The photo to the left shows why. Placing the girl in the middle of the frame empha- sizes her powerful expression and stance. The authority trumps the rule of thirds. In short, if the subject is strong enough, centering your child in the frame can work beautifully as well.

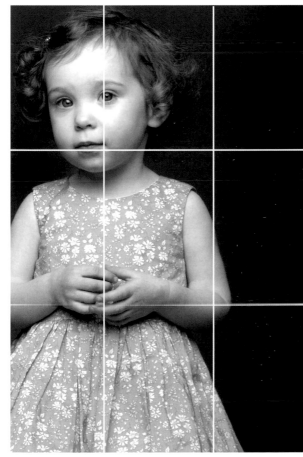

fig. 7

fig. 8 fig. 9

When cropping images, either in the frame of your camera or when post-processing, it is important to remember not to crop at the limbs. Figure 8 shows awkward cropping; if you see this while shooting, either step back to ensure you capture more of your child within the frame, or, as shown in figure 9, ask your child to reposition her arms so they are inside your original crop.

BALANCE

Identifying balance within a composition will come naturally the more you see it expressed. Balance works with the rule of thirds. Placing your child on one of the imaginary lines may result in too much negative space. You can use other objects to balance your child within the frame, strengthening the overall composition. But my favorite adage applies here: rules are meant to be broken. I encourage you to push the boundaries of this rule and see if you are pleased with the results.

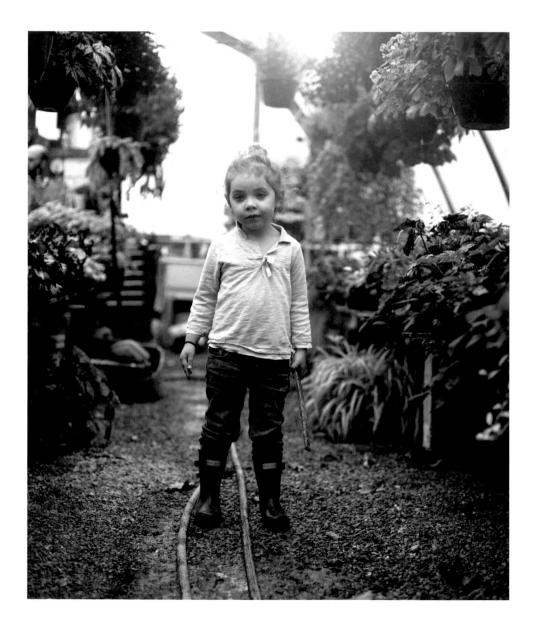

COLOR, TEXTURE, AND SHAPE

Visual interest is an important part of a successful photograph. Color can easily overwhelm a photograph, and I encourage you to be observant of your surroundings when you shoot. Brightly colored items in the background can really pop right off the photograph and steal the show. If you want to pay particular attention to color (in terms of clothing, props, and backgrounds), be mindful of the color wheel (figure 10). The primary colors, red, blue, and yellow, cannot be made by adding or mixing any other colors. Secondary colors fall between the primary colors, and tertiary colors fall between primary and secondary. If you study the hues on the color wheel, you will begin to see what colors seem naturally drawn to be paired. Start by choosing a color, and then drag your finger directly to the opposite side of the wheel. That is your original color's complementary color. You know what they say? Opposites attract!

fig. 10

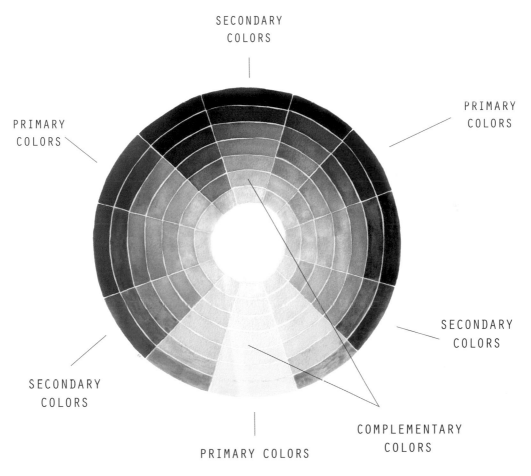

SECONDARY COLORS

PRIMARY COLORS

PRIMARY COLORS

SECONDARY COLORS

SECONDARY COLORS

PRIMARY COLORS

COMPLEMENTARY COLORS

Texture can also add visual interest. Whether it be the wales in the corduroy overalls your son is wearing or your daughter's raven curls, look for texture when you are photographing your child and challenge yourself to incorporate it into your compositions. Look for shapes as well. Shapes can be especially effective when repeated.

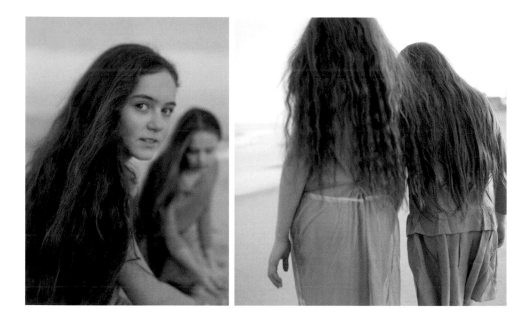

USING LIGHT AS A COMPOSITIONAL ELEMENT

We devoted a whole chapter to understanding light and using it well in your photographs. But there are other ways to wrangle that magic gold. Light can be used as a compositional element in several ways. Reflections and silhouettes are the most common ways of doing this. Look for reflections not only in mirrors, but also in water and most shiny objects. Children love to hold shiny things and see their own faces peering back up at them.

Creating silhouettes is much like creating flare. It's about your own placement in relation to your light source and your subject. By placing your subject in front of a light source (with enough illumination still shining behind her), you can create this look easily. Watch what your light meter tells you and try a few frames. You may have to underexpose the shot to achieve the overall look you want. Look for Irene Nam's portrait of her son in chapter six for some truly beautiful examples of this look. A third factor to consider is mood. Light can alter the mood of a photograph significantly, and its presence or absence can be the building block of a great composition.

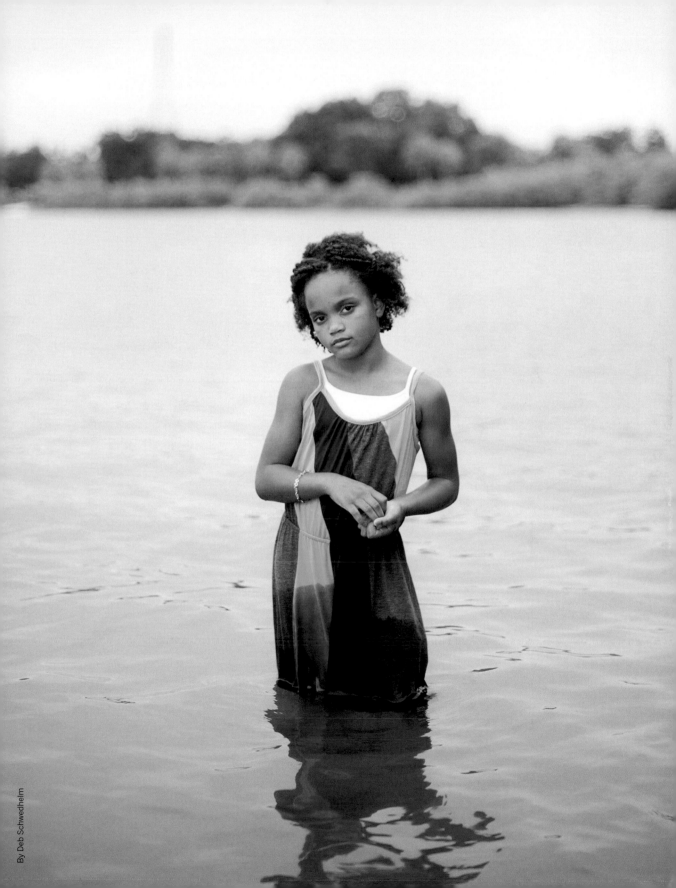

CAPTURING MOTION

A universal truth about children: if they are given the space to run and have the ability to do so, they'll run until their lungs ache. Just because your child is moving does not mean you need to put away the camera. There will be instances where the light is too low and it's nearly impossible to capture their movements, but there really is a way around everything, and in the case of movement, it's all about shutter speed.

Are you experimenting with shooting manually yet? I hope so! When photographing children who are moving, you will have greater control of the final image if you shoot manually. There are two things I invite you to try here. The first is to slow down your shutter speed to create motion blur. This beautiful artistic tool creates a photograph that is more an impression than reality (think of impressionistic paintings). Figure 11 was shot with a slower shutter speed, allowing the child to move through the frame while the shutter was still open.

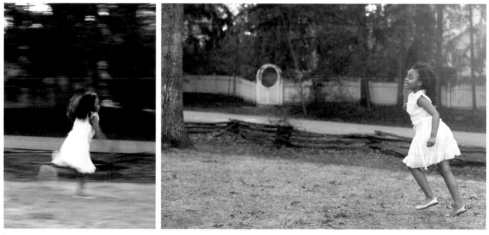

fig. 11 fig. 12

The second thing to try is to speed up your shutter. By balancing your f-stop and ISO with a fast shutter speed, you will be able to create your child's moving form quite realistically, as figure 12 shows.

CRAFTING YOUR STYLE

The more you shoot, the more you will see a cohesive style in how you shoot emerge. While it's important to explore the work of photographers you admire, it's much more important for you to

create your own way of doing things—a signature, if you will. It may be your use of light, the emotion and mood of your photos, or perhaps your use of color. Whatever it is, ensure that it comes 100 percent from your own heart.

When we discuss composition, we have the rules that we've talked about on the previous pages, but style is equally important. Think of the composition rules as the model and the style as the clothes: you need both to truly communicate your idea. Let's talk about how and what to shoot . . .

By Jennifer Way

DOCUMENTARY VS. EDITORIAL

There are two popular ways of photographing children. Documentary photography is just what it sounds like—you are documenting your subject. This style, also called photo-journalistic, has become a buzz word not only among children's photographers, but with wedding and lifestyle photographers as well. Capturing people and events as they are, not as we wish them to be, is thought to have the lasting beauty of realism. Editorial photography, on the other hand, has a preconceived notion about it. A stage has been set, if you will, and you are there to capture the players.

Both are effective ways of photographing, and I would like to encourage you to explore both. Think of taking your camera into your child's room as you wake him from a nap. The late afternoon sun is streaming through the window and dancing on your son's curls. Photographing that sweet moment as his fist gingerly comes to his eyes and his body coils and stretches his limbs—it's a beautiful moment to behold, and one as natural as can be. Be observant of these little moments and document them when you can. You will soon have a feel for what you enjoy photographing and what moments you are comfortable with letting slip by quietly.

Creating a more staged environment can be fun as well. If you and your children are enjoying the moment, I see it less as contrived or staged, and more as creating another world, more stories, more beauty for your children to explore. Your children really have to be on board with this idea, so the more interesting the story you create to shoot is, the more likely they are to play along. My daughters, like most young ladies, adore a good tea party. On this particular occasion, we took the party outside, brought out books and drawing materials, berry tarts and lemonade, and just let them be (page 73). Give them the tools and they will create their own stories, and you can quietly observe the magic unfold before you.

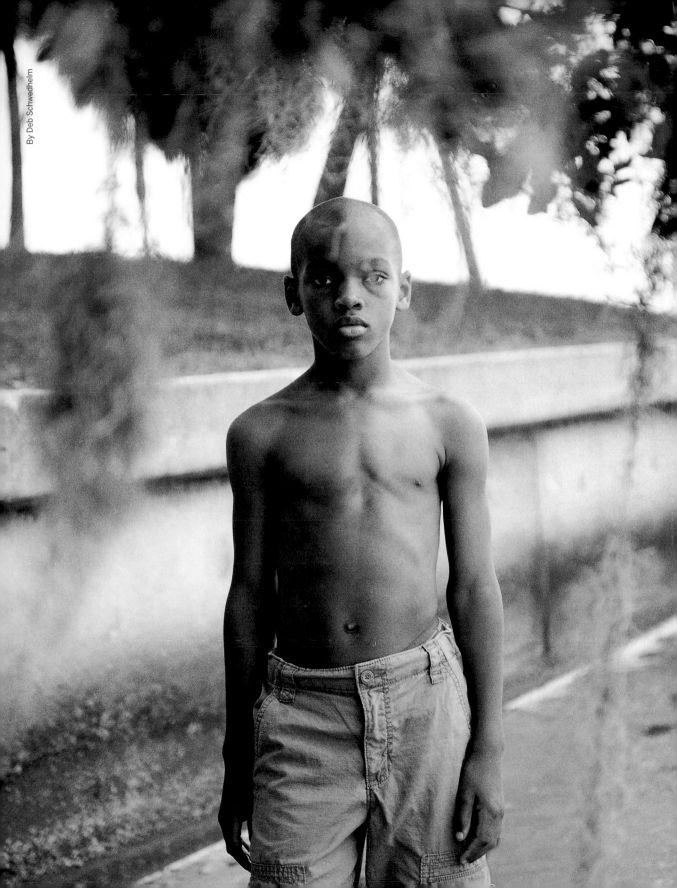

STORY SETTINGS

» Backyard and living room forts—overflowing with blankets and pillows

» Little picnics

» A scavenger hunt

» A backyard teepee filled with their favorite things

» A day on a local farm

» A painting party. Dress your little ones in big white tees, put some canvas out in the grass, and let them go for it!

» An easy photobooth made from a sheet or large tablecloth hung between two trees with a trunk of dress-up clothes, hats, and accessories.

» An ice cream bar with self-serve toppings.

» If you're brave enough, prep everything for your kids to make cookies or cake.

» A casual spa day with girlfriends for an older daughter.

» One word: sprinklers.

» Ask your children what THEY would like to do or pretend. You may be amazed with the ideas they come up with.

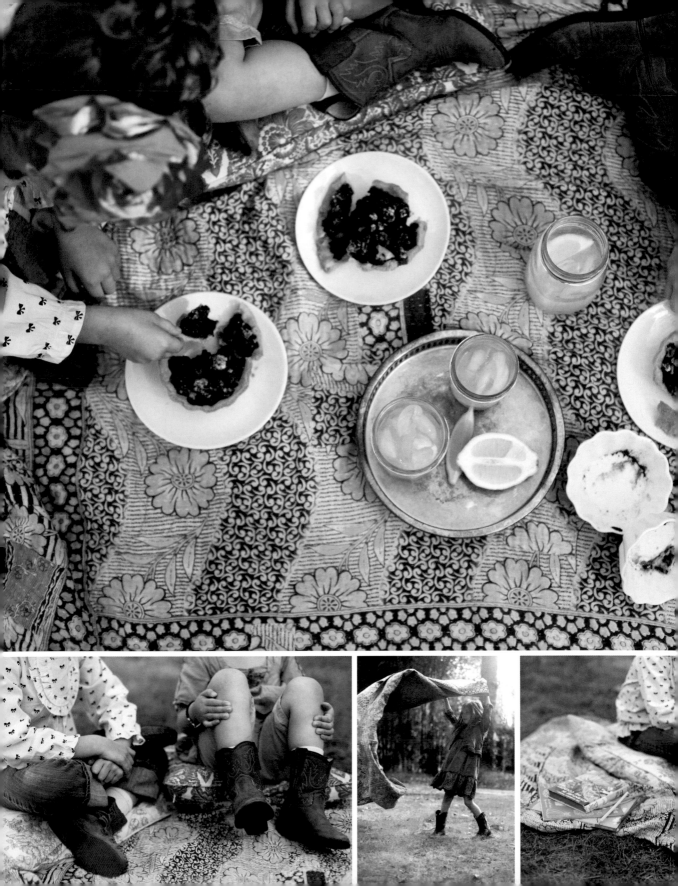

IDEAS FOR VISUAL STORIES

Childhood is a beautiful sequence of stories to be told and tales waiting to unfold. As both the parent and the photographer, you will likely be able to look back on the photographs you take over a given year and remember where you were, even perhaps how you felt in that moment. But others may not. If you hope to share your photographs with others either online or as gift books for grandparents, the visual impact can be so much greater if you attempt to tell stories.

Every photograph is a story, real memories to those involved or impressions to casual observers. But when photographs are sequenced, they can help create a more cohesive story. Years from now they will help you recall these events with clarity. Some ideas:

> » *Try sequence shooting.* When photographing your child doing something, take a shot every 10 seconds or so. This seems an obvious way to let a story unfold, but looking back on these photographs will be so much fun.

> » *Don't forget the details.* Photographing children is not just about their sweet faces. It's also their beautiful, delicate hands, those sweet toes, their bellies. Non-facial shots are important in the story-telling process as well. If you've been a parent for some time, you know how fleeting these moments are. The children grow so fast, and you'll be grateful to be able to look back on these photographs and recall the perfect details.

> » *Additional details can be captured as well:* their favorite toys and books or favorite corner of a room. All of these elements help tell a story about your children's lives.

> » *If you decide to create a book of photographs* (as we will discuss in detail in chapter seven) try organizing them chronologically or by season to tell a story for a given year.

Creating these stories should be authentic, and it should always reflect your child's true and unique personality. No one knows your child better than you do, what makes her happy or sad, what she loves, and what she loathes. As parents, we are naturally wired not only to make these behavioral observations about our children, but to act upon them to meet their needs. We nurture the wonderment of it all. You are a natural observer as a parent. Work to translate this skill into your photographs. That smirk she gets when she's getting her way—you never want to forget that; the wide eyes as he learns to read a new word—keep your camera handy.

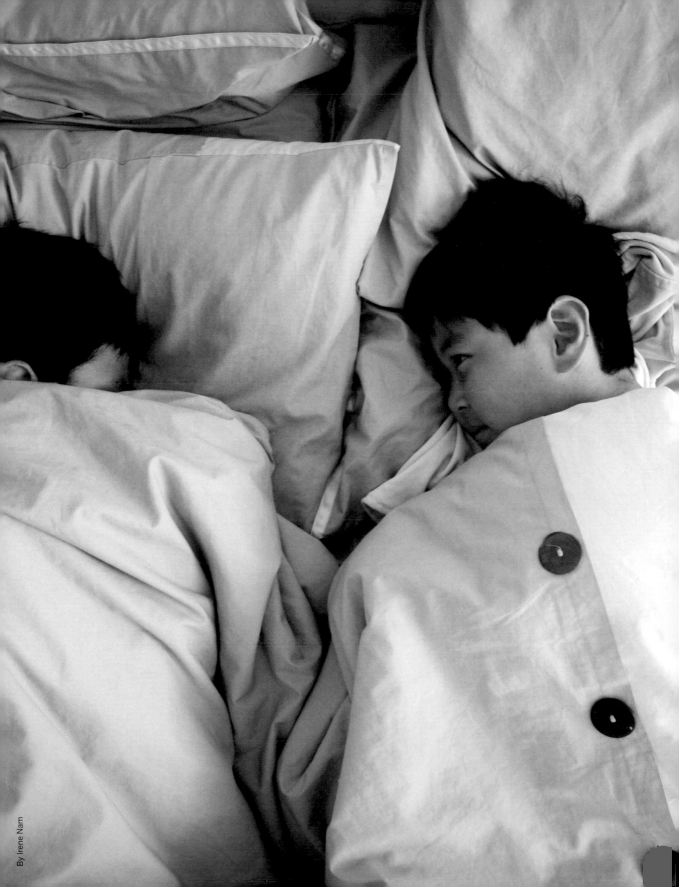

Some of you may be asking: do we really photograph everything? The answer is so personal—you take pictures of what you are comfortable photographing. When I first started to take photos of my own children, I joined Flickr and became involved in some of the children's photography forums. Occasionally, I would come across pictures of children crying or in the midst of a tantrum. At the time, I was horrified. As a new mother, I could not understand what would possess someone to pick up a camera rather than the crying child at that moment. In a way, I still feel this way. But of course, tears and tantrums are the reality of childhood as well. You need to decide for yourself what you are comfortable with and what you are not.

The image to the right is one of the rare times I have photographed one of my children crying. We had just moved to North Carolina from Brooklyn, and we were waiting for the bus to take the girls to their first day of school. Adie, my eldest, was sick with worry, and I had been trying to soothe her frayed nerves all morning, but she could not keep her tears at bay. Conversely, her little sister was so excited and could not understand why Adie was carrying on so much. I photographed them like this just before the bus arrived because I was not going to get them both smiling, this much I knew. But in retrospect, it's one of my favorite photographs because of the authenticity and raw emotion involved. Tears stand in my eyes every time I see this photo, and they likely always will.

You've learned in this chapter that creating beautiful compositions is not only about the "rules" of composition, but the emotion as well. It is your opportunity to create a visual story and capture small moments of time that will stand as testaments to your children's youth. Exploring the means of creating beautiful and unique compositions also allows you to discover yourself as an artist and create your own style of shooting, one that exhibits your confidence and results in gorgeous imagery.

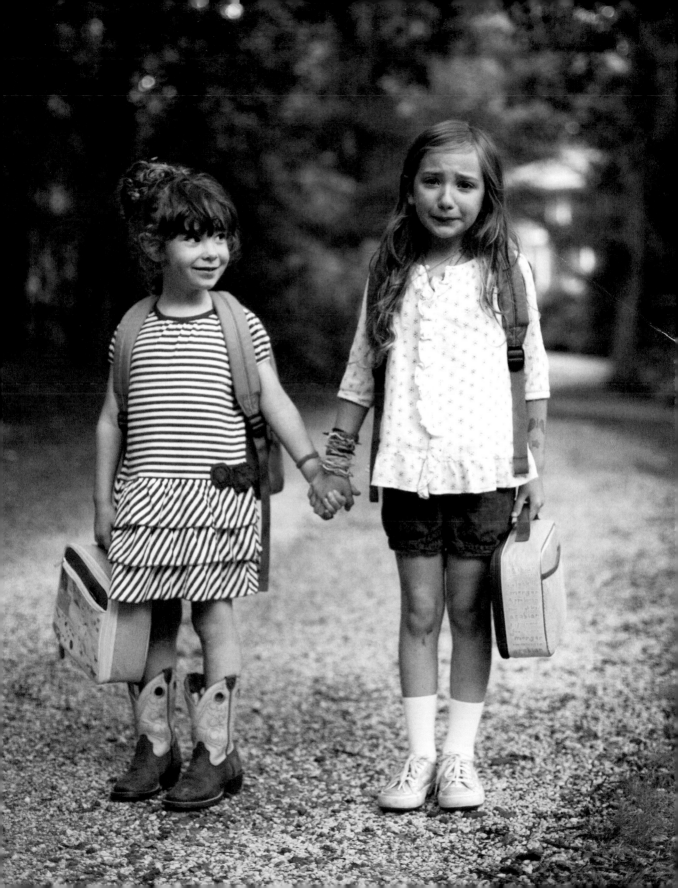

CH. **4**

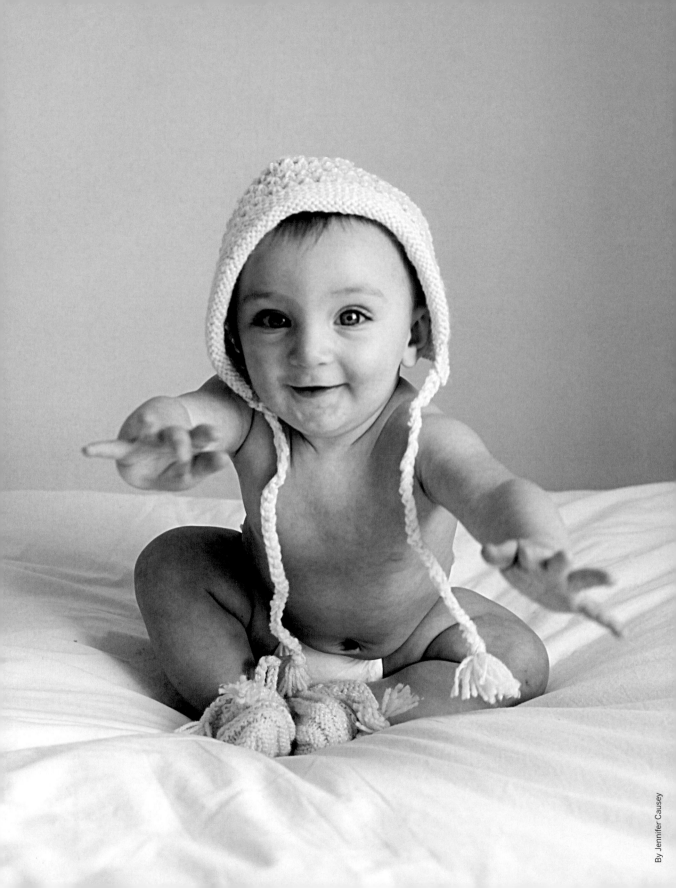

PHOTOGRAPHING INFANTS

When you bring your little love home, all you want to do is hold them. To feel that soft little head under the crook of your chin, to examine and reexamine the perfection of their little bodies, to sigh at the beauty of it all. Eventually, the dreamy haze breaks just enough that you feel a deep-seated desire to share this beauty with everyone, and the camera comes out. So do you put your infant in a flower pot or balance him precariously on a stool? My answer would be no. I appreciate the art form of infant photography, but I lack the understanding of the way it has evolved into placing infants in unnatural places like inanimate objects. Keep your images as natural as possible, and you will not have to look back on them years from now and say, "What was I thinking?"

Natural environments are timeless and will always create the ideal backdrop for your baby. Beds with crumpled linens, a family member's loving arms, and a favorite baby blanket will always be beautiful and natural. In this chapter, I will share some thoughts and visual ideas about how to best photograph your infant and review some special considerations when photographing babies.

When your baby is first born, picking up a camera may not be at the top of your list of things to do. If one parent is more interested in photography than the other, this might be the time to encourage some creative teamwork. Mamas tend to be otherwise engaged with feedings and unstable sleep schedules and may not have the energy to photograph anything in the first few weeks. Dads, too, are facing new challenges and are sleep deprived, but don't let this discourage you from trying. If you find yourself simply unmotivated (because truly your time is better spent snuggling of course!), hire a professional to come in and shoot for you. You don't want to miss this time. If you are indeed up for the challenge, here are a few considerations.

» It is best to ensure the baby is ready. How do you know if a newborn is ready? Your best bet is to shoot after they've nursed and have a clean diaper. They are likely to fall asleep and will be easy to move gently as needed.

» If you plan on shooting a few bare shots, realize that your child *will* pee and poop while you are shooting. It's not the end of the world, and it's actually pretty funny. Simply make sure you have not placed the infant on anything that will stain permanently, and be patient. Clean the mess quickly and gently so you do not disturb their slumber, and keep shooting!

» Get up close. Your baby's skin is silk and will glow under the right light. Get as close as you can and capture this luminescence. Don't forget the details here: baby toes and fingers, belly buttons, their fine hair and little tush! (NOTE: Many babies will experience baby acne about three weeks after birth. Be sure to get some close shots of your child's face before this. It usually only lasts a month or so.)

» Using texture as a compositional element can be especially useful with infants. Baby blankets, swaddling, and linens all add visual interest to the composition without taking the focus away from the star.

Within just a few weeks, the challenge can be a bit greater, because the baby does not sleep for such long stretches. However, as their eyes begin to acclimate to their surroundings, you may be surprised how quickly they will engage with a camera. This is the time that they also become increasingly responsive to sounds. And within just a couple of months from that point, they will likely be sitting on their own!

» Try holding a baby toy, something that makes a pleasant noise, just to the side of your camera or above your head.

» If he is lifting his head, place your baby on his belly and get down on your own in front of him.

» I love arm shots; nothing says love like a baby peeking from the folds of a parent's arms.

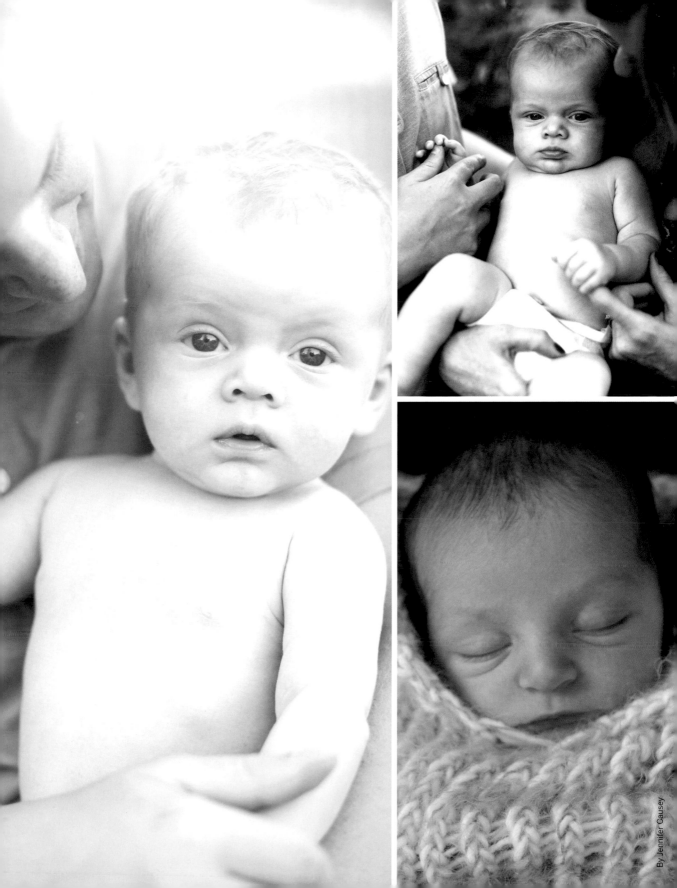

» Regardless of how you are photographing your child, it's always important to speak in a soft, warm voice so they stay relaxed and comfortable. If at any point your child shows discomfort or irritation, use your instincts to put the camera aside for the time being.

» When your child begins to sit, be mindful that they do not truly have a stable seat. Be sure to prop them against something for support and ensure that their surroundings are soft enough that if they lose their balance, they will not go bang! Large beds are the best bet.

» Give your baby space. The photograph in figure 13 works so beautifully because the child is the focus. In terms of safety, when placing an infant on a bed like this, ensure that they are in the middle so that if they begin to explore, you have enough time to move from your vantage point to your child!

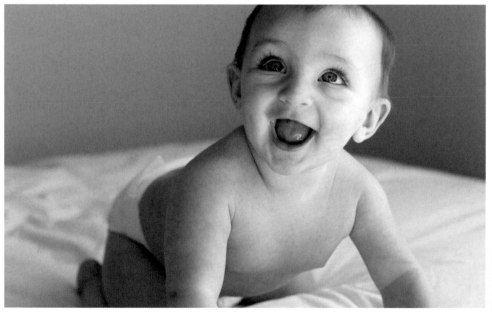

fig. 13

By Jennifer Causey

Finally, a baby will really start moving. That's the game changer. Once a child has learned to crawl, she wants to move, move, move! Be flexible, be patient, and be safe. Your child does not really understand any commands at this point, no matter how sweetly delivered, so asking them to stay put is likely useless. Learn to move with your child, spend time on your hands and knees exploring with them, and photograph them naturally; you will truly be honing your documentary style at this point. Embrace it!

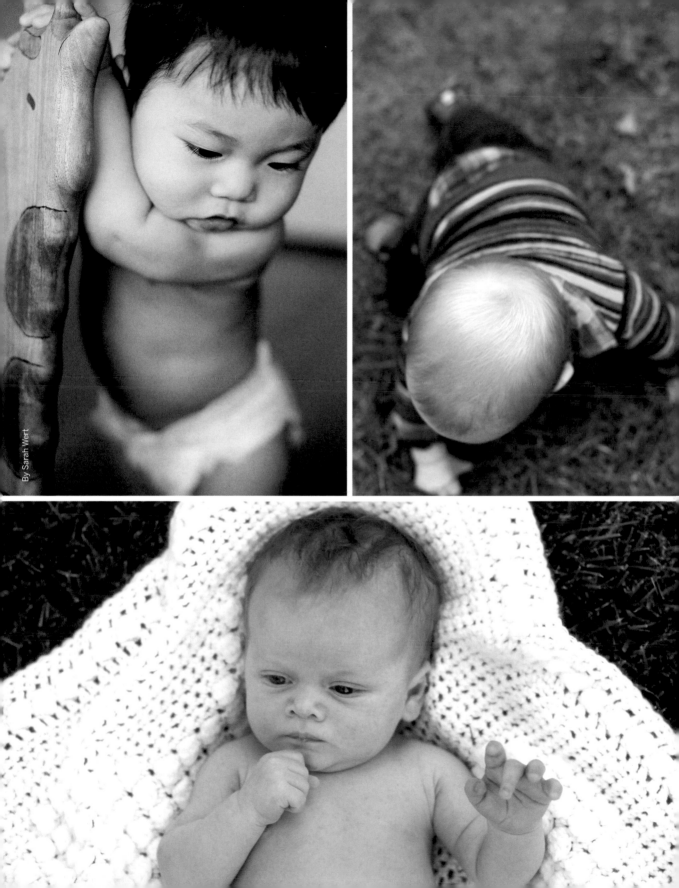

CH.

5

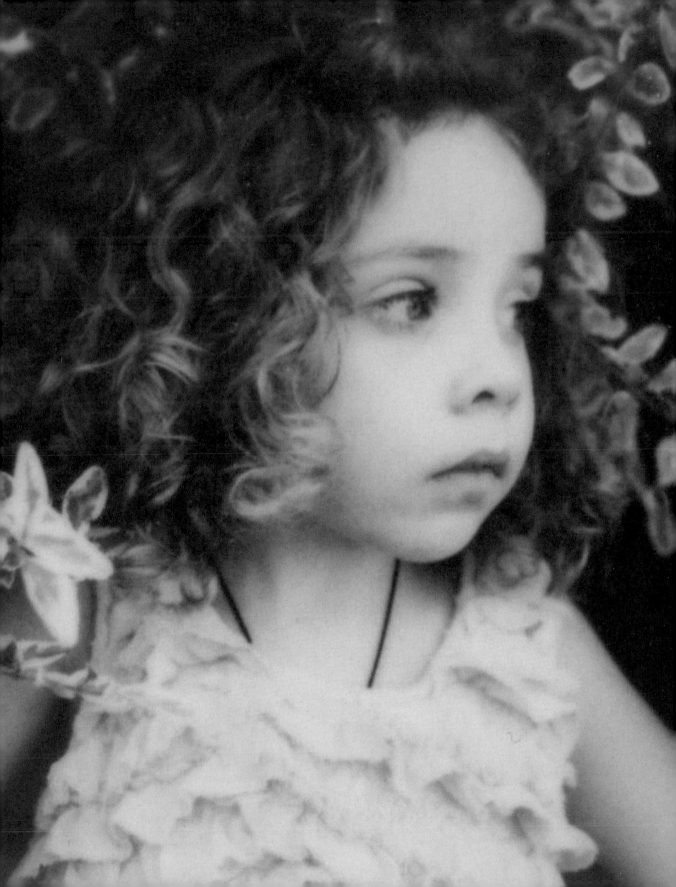

PHOTOGRAPHING TODDLERS & YOUNG CHILDREN

As your children grow, so do their personalities. Photographing older children can be a bit more challenging than photographing infants, but it can be incredibly rewarding as well. It starts with getting your child comfortable with the camera. Unlike still lifes or food, portraits offer a new challenge in that your subject can—and when it comes to a child, does—move. The most important tool in composing your portraits is your patience. Often kids are fatigued by parents asking them to look at the camera and smile. They begin to see your photographing them as a necessary evil—one that often earns parents tight, forced smiles, and even eye rolls. Especially if they have not grown up around photographers and are not used to being photographed regularly, children don't know exactly what you're asking of them, even if you have a clear vision in your own mind.

It can be helpful to acclimate your children to your new hobby by simply photographing them in a very casual way on a regular basis. Do not ask them to look at you, do not ask them to smile. Capture the moment as they are living it, not as your mind is willing you to see it. If they turn to you and force a smile, tell them to continue to play and to pretend you're not there. If they turn to the camera and make a funny face, laugh with them, shoot a few frames, show them the photograph on the display screen, and share a giggle. Reprimanding is a sure way to elicit their resistance when you pull out your camera. Though my girls are very comfortable in front of the camera, my middle daughter went through a "face-phase"—she could not resist pulling a funny face whenever I turned the lens on her. Though children can find this endlessly entertaining, as a parent, you may say "all right already!" What the experience taught me was compromise. I did not want to tell her

she couldn't make faces anymore, but I needed her to follow simple directions in terms of what I wanted to shoot as well. So we found that taking five to ten funny face shots and letting her giggle over them would allow her to get the silliness out of her system—at least for a little while!

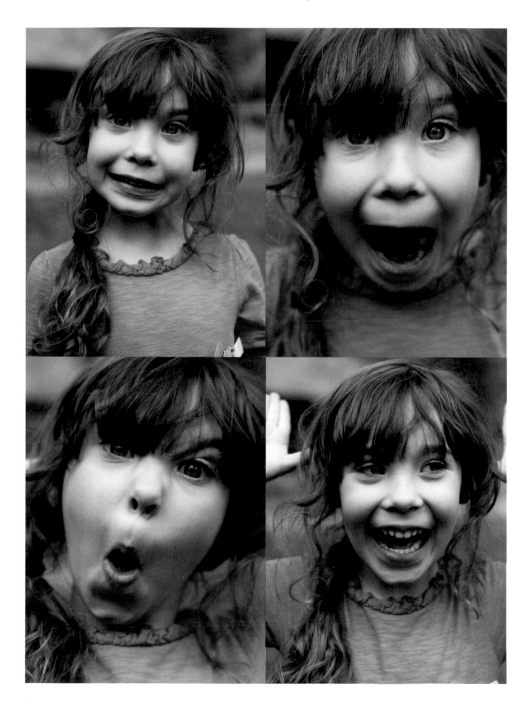

ANTICIPATING THE SHOT

One of the advantages of shooting digital over film is that you do not have to worry about processing costs and time. You can take the photograph, view it immediately, and decide whether it's a keeper or destined for the virtual trash bin. There is an adage in digital photography that defines a way of shooting: "spray and pray." It means that you shoot, shoot, and shoot (spray) and hope (pray) that you were able to capture something passable. With toddlers especially, this can be a tempting way to work. But I highly discourage you to rely on this method. What makes a photographer great, what makes his or her work unique, is the gift of anticipation. And this, like so many things about parenting, requires patience. I know, it can be difficult. As a mother of three girls, it is a recurring lesson for me on a daily basis. But the rewards are endless, not only in the image you are likely to capture, but in your evolving relationship with your children as well.

Place your eye to the viewfinder and let your index finger hover over the shutter button. Take a deep breath. When you see an expression that makes your heart skip a beat, shoot. If your child is not paying you much attention (although this can also create beautifully authentic imagery in its own way when they are lost in their own world), you can engage him. Tell a joke, ask him to tell you a joke, talk about your day, ask him about his—all the while anticipating that shot. If you see something you want to shoot, but maybe her face is too dark, there is nothing wrong with gently coaching your child, "Look at the window, what do you see out there today, love?" Older children can follow more specific directions, such as, "I love where you are looking right now, can you just move your eyes toward me?"

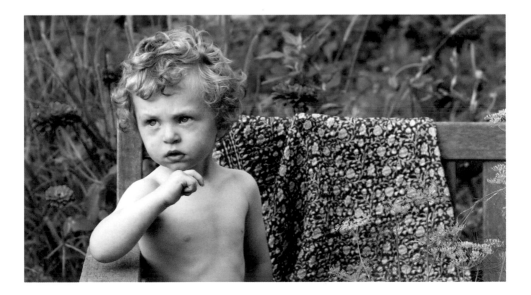

ADDITIONAL THOUGHTS
TO ENGAGE YOUR CHILD

» Ask your child to sing their favorite song.

» Give your child a favorite toy to cuddle or play with (even better, a toy they haven't seen in a while, it will be like it's brand new!)

» The sheer delight children find in ice cream cones and popsicles will never die.

» Kids often really turn it on when friends are around. It can get crazy, but it's fun to capture this energy.

» Encourage them to play dress-up. They will love seeing these photographs later.

» Watch their expressions when they learn something new. It's something you never want to forget.

» Find wide open fields for them to explore; discover the blooming schedule for wildflowers in your area to photograph your child walking through.

» Remember the firsts: the first sledding day of the snow season, the first tooth lost, the first time using the potty—these are big moments.

Reality Check It's wonderful to think about all those opportunities and moments ahead just waiting to be photographed. But do remember not to be hard on yourself in terms of shooting too much, or too little. Life with children is the greatest of joys, but it's also hard. Do not give in to outside pressures to keep a camera in your hand 24/7—even on holidays and birthdays. I learned a valuable lesson a few years ago regarding this misplaced guilt. When my oldest daughter turned six, we threw her a Country Fete birthday party; we rented out a beautiful old barn that twinkled with fairy lights, and the picnic tables were covered in country linens topped with wildflowers in galvanized tins. We created a photo booth with a pinned up floral sheet backdrop, and the kids sat on an old saddle atop a leather trunk. Another trunk overflowed with scarves, chaps, and cowboy hats for the children to use as props. Peggy Lee and Johnny Cash crooned in the background. It was amazing. And the only photographs I have to show for that day are the photo booth shots. Later, when I realized it was all over and I had not photographed ANYTHING, I was mortified. I was reminded by Adie's embrace and enthusiasm for the day that I had a wonderful time, and I'm not sure that I would have if I had been concerned with taking a lot of photographs.

The more you take and share photographs with your friends and family, the more these people will expect you to become the family photographer. And it's okay to gently decline this request on occasion. You have to remember that living these moments is so much more important than photographing them. If you are throwing a party for your child, take a few minutes before it starts to walk around and capture the details or your child in their birthday best. Then, if you are so inclined, keep the camera with you, but do not pressure yourself to photograph everything. Or you can do what I do, which drives my mother nuts, and put the camera away. It was one of the hardest, but most rewarding lessons of my life.

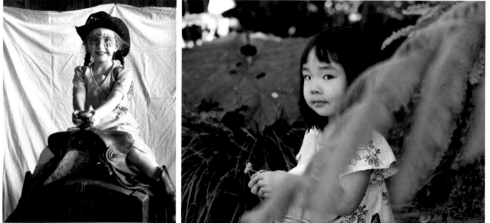

By Sarah Wert

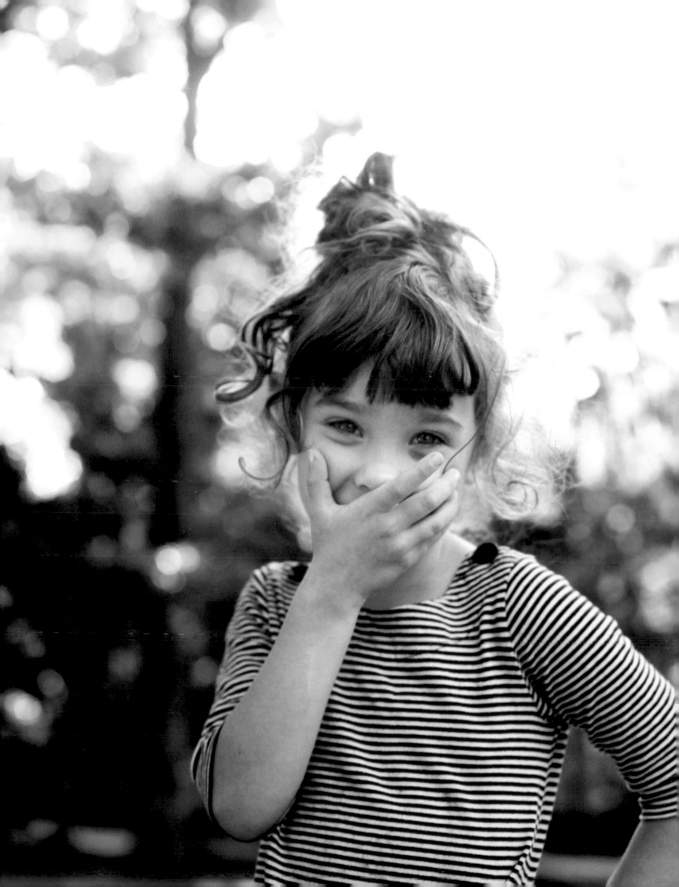

CH. **6**

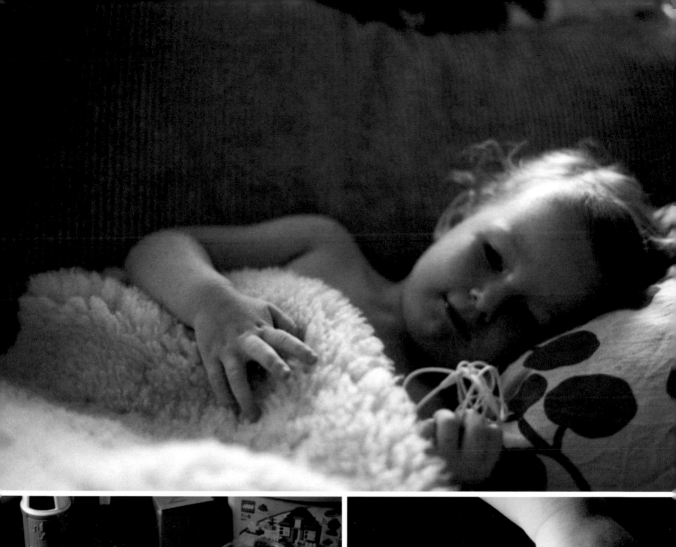
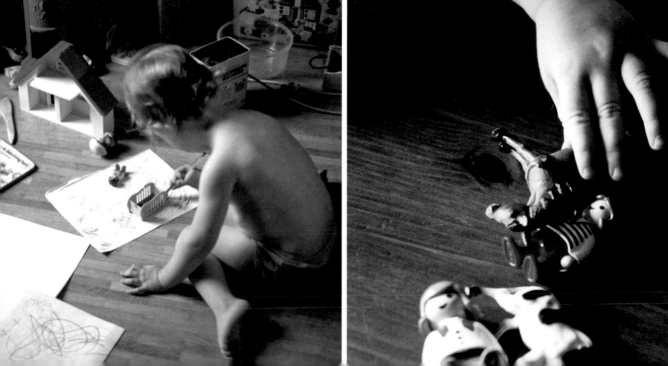

As parents, we see our children a little differently than the rest of the world does. We believe them to be unique in their beauty, innocence, and joy. Nowhere can this be more thoroughly expressed than when a mother or father photographs their own children with the entirety of their heart and soul. Love radiates from the image. It is not something that can be replicated in a photography studio or in a photograph taken by a stranger—it is a unique alchemy between child and parent that brews such magic.

In this chapter, parents share the reasons they photograph their children—not simply to capture a smile and happy holidays, but to embrace the beauty of quiet moments, faces they alone know as well as their own. Some are professional photographers; some of them just simply love the medium. I hope they inspire you to seek opportunities to photograph your child in a new way, challenging you to create gorgeous, authentic imagery and, above all, to create magic.

JÖRDIS ANDERSON AND MATHIAS MEYER

www.beagoodgirl.net and www.holgarific.net

Jördis, Mathias, and their three-year-old daughter Mari live in Berlin, Germany. They own way too many cameras. Photography for them is a way to document their daily lives, and they enjoy taking pictures not only of Mari, but also of the children of their friends and families.

1. What do you enjoy most about photographing your family? We enjoy capturing moments. When we take pictures of our family, we strive not for the perfect portrait or photo, but to capture those happy times and also the times when things are not so great, when our little one is sick or when she's having another one of her little mood swings. It's what defines us as a family, and it's these moments that shape us.

2. What is your favorite camera to shoot with and why? While a digital camera is a great tool to take pictures of kids and family, it's the film cameras that took our hearts. There's just so much more atmosphere in film and Polaroid shots. We shoot with a Nikon D80 every now and then, to do quick photo shoots with our tiny little princess, but Jördis's, favorite is the Pentax ME Super, a 35mm film camera, and Mathias enjoys shooting with his Pentacon Six, a medium format camera. We do enjoy taking out a Polaroid camera every now and then, too. It's a special treat for our little one, too, because she gets to watch the photos develop.

3. How would you define your style of picture taking? Do you think it's important to cultivate a style or just to shoot? Our style of picture taking evolved before we had Mari, and it has certainly had a big influence on how we take pictures of her. We try not to take an abundance of snapshots and choose the best ones later. We try to capture a moment as well as possible. In general, we don't take pictures all the time, but only when it feels right. You can take all the pictures in the world of your little one, but don't forget to live in the moment instead of feeling the urge to capture it. We don't think it's important to cultivate a style, as over time, you'll automatically start developing your own.

4. How do you keep your daughter interested in having her photograph taken? We try not to overdo it with taking pictures of her, so we can keep her engaged whenever we feel it's a great moment to capture. Believe it or not, we even forgot to bring a camera to the hospital when our daughter Mari was born. One important thing we've always done is show her the pictures we've taken. We go through them, and she thoroughly enjoys looking not just at her photos, but at all the ones from a trip, from a day out, or a day spent at home making pizza dough.

5. What advice would you give to those who are ready to hone their artistic eye in terms of photographing their children? Try not to force it; don't give in to the fear you may miss capturing a special moment with a camera. If you do, you'll miss these moments, and no photo in the world will bring them back. Take pictures of your kids in their natural habitat. You'll be much happier looking at pictures of them playing, when they're outside, when they're having their greatest moments.

We like taking pictures of little details, too. It's about telling little stories, something which is more important to us than having a large collection of portraits of our little one. If you do take a lot of pictures, it's okay to delete some of them. Go through them, find the ones that make you smile, keep them, and delete or archive the rest. These shots are the ones that really matter.

MELISSA FRANTZ

www.allbuttonedup.typepad.com

Melissa Frantz is a Canadian expat living with a house full of American boys in Portland, Oregon. She never considered she would be a parent to three small boys, even though it all seems to make perfectly good sense to her now.

1. What do you enjoy most about photographing your family? When my oldest was a baby, I was so taken by his every look and quirky gesture that I tried to capture it all on (what was then) film. As my family has grown, my favorite thing to try to capture is the dynamic between all three of my boys. Documenting their relationship has become the most important part of our family photo collection and highlights the differences between their personalities better than I could have imagined.

2. What is your favorite camera to shoot with and why? I don't think I own my favorite camera yet! I shoot with a very basic Canon DSLR, but my heart still belongs to my Canon AE-1, even though it mostly sits in a drawer unused. I do have a favorite lens: a basic 50mm. It forces me to move around and really prioritize what I'm trying to capture. It also does great things in low light, which is key since I don't use a flash.

3. How would you define your style of picture taking? Do you think it's important to cultivate a style or just to shoot? My style has been defined by the constant movement of my boys. Almost every photo contains a blurry hand or a foot that has left the pavement. When my oldest was quite young, I began to take photos of him by our front door or sitting on the front porch. Now that area documents everything from the first day of school to a new haircut. I think it's important to shoot a lot of photos—but I think the way that you grow your style is to cull those photos down to the very best ones and get rid of the rest. It is in the editing that style is really born.

4. How do you keep your kids interested in having their photograph taken? I don't! If they don't want to cooperate, they will go out of their way to make things interesting. The only way I can occasionally distract them is to ask them to sing me a song or tell me a story. Sometimes the best photos happen in those few seconds while they try to think of something to say or decide on a key change. They all go through phases of wanting or not wanting the camera around, and I have just had to learn to go with it.

5. What advice would you give to those who are ready to hone their artistic eye in terms of photographing their children? Decide what sort of pictures are most important to you and what sort of pictures you're going to want to look at in ten or fifteen years. Don't worry about pleasing the grandparents or your social media contacts or even the subjects in your photos! Once you start taking pictures that you really love, you'll notice that there are certain things about the "best" ones that say something about not only the time and the place, but also about the personality of your subject.

CARISSA GALLO

www.carissagallo.com

Carissa is a photographer who grew up in southern California and now lives with her husband, Andrew, and their daughter, Rinah, in northern Virginia. Their family was united during the fall of 2011, when Carissa and Andrew finally brought Rinah home from Uganda. They are constantly pursuing the creation of innovative and implosive art. The love and unity within their family is the fuel that they use to create. Nature, words, music, and other humans help, too.

1. What do you enjoy most about photographing your family? This year, the man who inspired me to pick up a camera was no more on this earth. My grandfather gave me many cameras and showed an interest in my photography without fail. When he died, I went through thousands of photos that he'd taken. I saw my father when he was little, and I learned more of my history. The thought of my children's children doing the same thing brings me great joy.

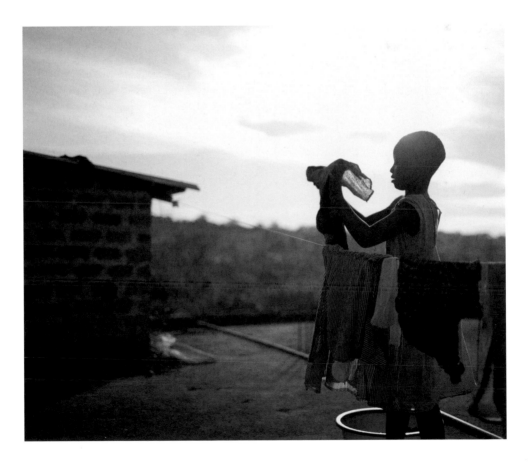

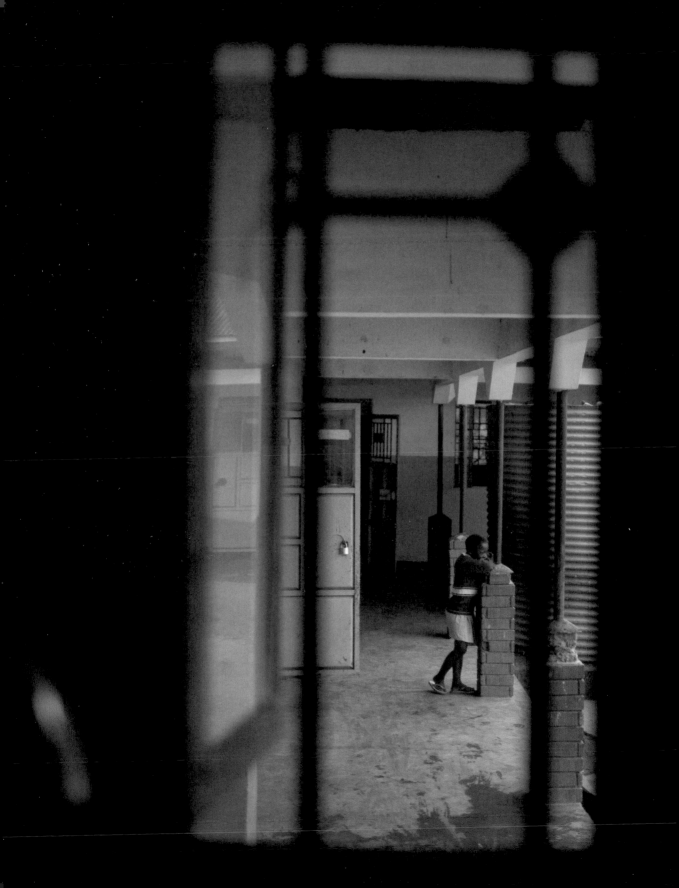

2. What is your favorite camera to shoot with and why? I shoot with my Canon 5D Mark II more than any other camera. I know it well, and I think it knows me well, so we work together like old friends.

3. How would you define your style of picture taking? Do you think it's important to cultivate a style or just to shoot? I think it's important to shoot what your mind's eye finds beautiful. I am the only one who sees through my eyes. I want to capture what I see, the way I see it. I think a style will develop through that alone. Attempting a certain style from the beginning could hinder becoming who you are as a photographer. Cultivating the art of capturing those you love, how you see them, is a beautiful thing!

4. How do you keep your daughter interested in having her photograph taken? It's a little unique for us: our daughter spent her first eight years in a place where cameras are still extremely novel. The first time I went to where Rinah lived in Uganda, I almost avoided taking my camera out of its bag. The moment I did, I had a mass of children crowding around me, waiting for me to take a photo of them to then show them the tiny image on the back of my camera. Rinah still has that in her, in some ways. She is still just so excited to see what a camera can do. Sometimes I have to be more like a paparazzi than anything, so I can capture her before she notices me.

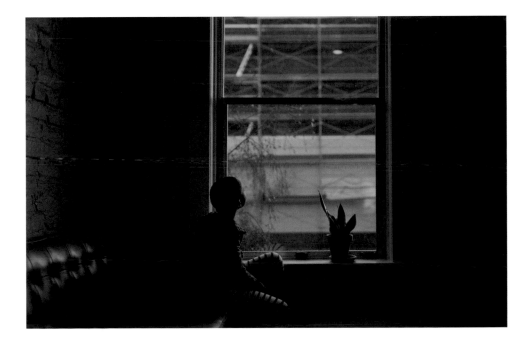

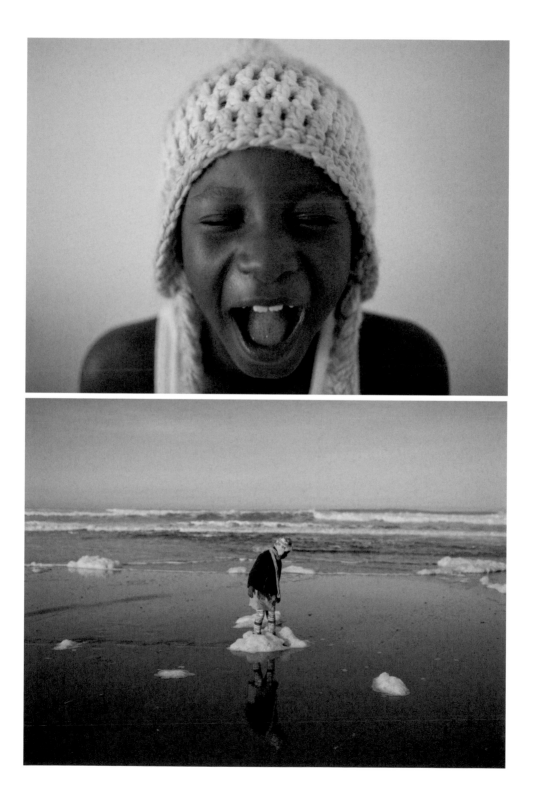

5. What advice would you give to those who are ready to hone their artistic eye in terms of photographing their children? You love your children like nobody else does, and your children are more comfortable with you than they are with anyone else. Because of this, you have such a unique opportunity to capture them as who they are. I think everyone should just start shooting with whatever they have, be it film or a phone.

HANNAH HUFFMAN

www.flickr.com/photos/haeshu

Hannah Huffman lives in Southern California with her husband David and her three children, Eliot, Collette, and Arlo Jane. By day, she tromps around construction sites, keeping people compliant with environmental regulations, and by night she tries to spend as much time with the camera as possible. A dozen or so years ago, her husband gave her an old film camera. She loaded a roll of film (backward), and came back home with nothing. So she promptly shoved the camera in the closet and forgot about it for a few years until her son was born. She followed him around with a cheap point and shoot for awhile, then dug around in the closet for the old camera and never looked back.

1. What do you enjoy most about photographing your family? I love having a collection of images that tell the story of our family. I've been taking pictures of my family nearly daily for the last seven years. I find that time and time again, somehow the camera manages to capture moments that are almost overlooked, even in the moment. Without fail, it's these photos that I treasure the most. It's important to have pictures of my children smiling dutifully at me, lined up in a row on the sofa. I have them, and they keep my mother happy. But it's the photos of my son laughing, or the girls twirling around in the backyard, or the tears from the scraped knee that I will love for ever and ever.

2. What is your favorite camera to shoot with and why? My Nikon DSLR is invaluable for shooting every day, but it's my Pentax K1000 that is my favorite. Shooting film feels wonderful, and there is something about the stripped down simplicity of the K1000 that is so satisfying. Slowing down to think about the manual settings of the Pentax has also translated to and improved my digital photos. What's not to love about that?

3. How would you define your style of picture taking? Do you think it's important to cultivate a style or just to shoot? I really do enjoy the magic and beauty of everyday life. My most favorite photos are always those of people laughing. If you shoot what you love, you'll want to do it, and you'll keep doing it, and eventually you'll get better and better.

4. How do you keep your kids interested in having their photograph taken? I'm not going to lie, in the beginning it was straight up bribes. I think I let my son eat a whole sleeve of cookies once, just to get the shot I wanted. Eventually though, your children will get used to having the camera around all the time. Also, listen to their suggestions, and take a few photos the way they would like to see them. They get excited to pose and get more excited looking through the photos later.

5. What advice would you give to those who are ready to hone their artistic eye in terms of photographing their children? This may sound scary, but turn your flash off and switch your camera to manual. It will really help you learn how your camera works. Natural light is your friend. Take your child over to the window or the open front door and take a few photos—you'll see what I mean.

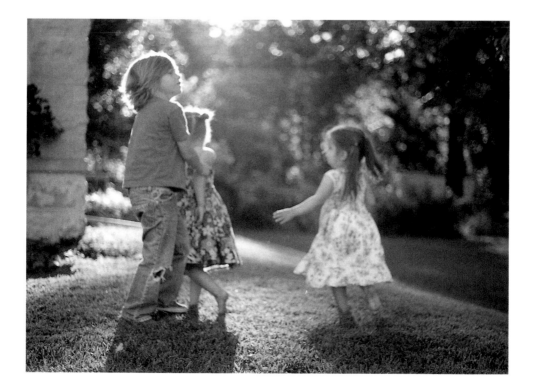

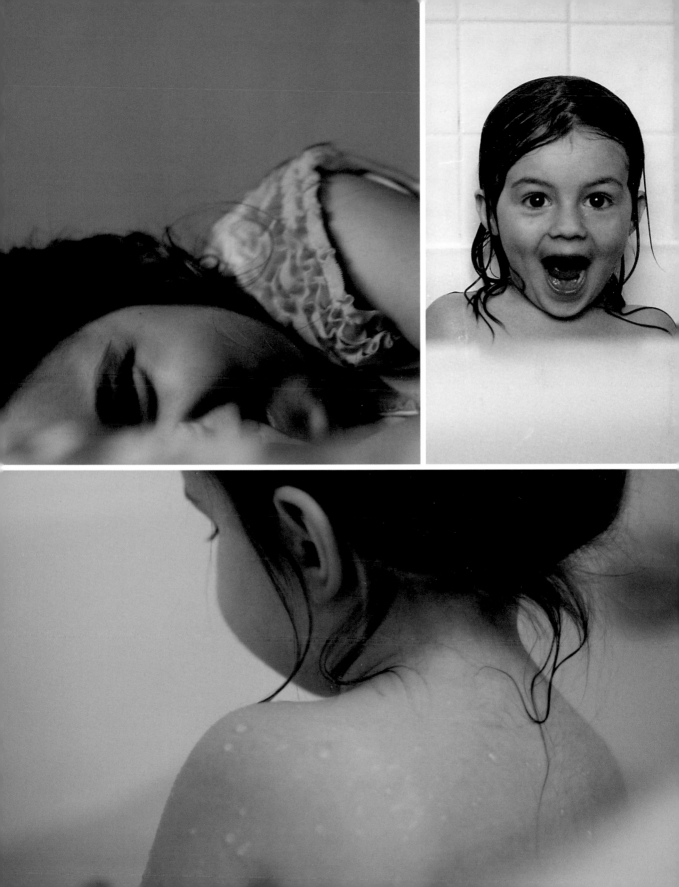

RYAN MARSHALL

www.pacingthepanicroom.com

Just before becoming a husband and father, Ryan decided to run from the regular nine-to-five life to give his dream of being a photographer a try. So he quit his sales job and dedicated himself to studying photography, and he chronicled his mistakes and triumphs online on his blog, Pacing the Panic Room. It became the home base for the story of the building of a family and his career.

1. What do you enjoy most about photographing your family? Every time I take a picture of my family, I imagine them opening up a box twenty years from now and finding all these photos inside and just filling up with memories, and smiles, and love.

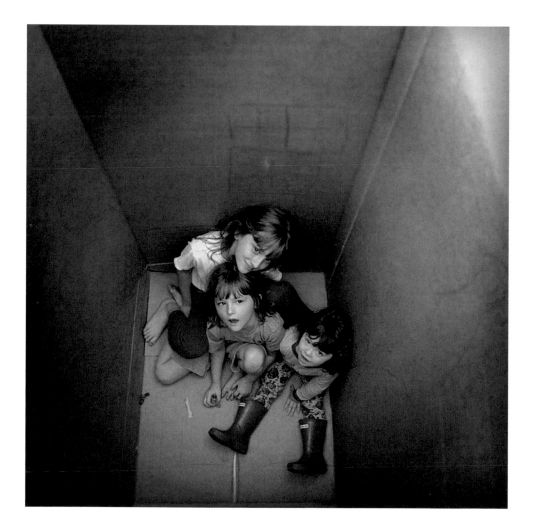

2. What is your favorite camera to shoot with and why? A couple of years ago I finally bought a Polaroid 600SE "The Goose." From the first pack of film I shot, it instantly became my favorite camera to use around the house. There is just something about yanking the film out the side of the camera, letting it cook, and then peeling apart a gorgeous looking finished photo. But I also quickly found that the kids act the most natural around the iPhone, so I started using it like crazy. There is no other camera I own that I get this kind of candid shot with.

3. How would you define your style of picture taking? Do you think it's important to cultivate a style or just to shoot? With the massive amount of photo sharing that goes on online these days, I feel like it's important to cultivate your own style. I'm often confused when I see so many people follow trends, or when people all start using the same filters and actions, and all of a sudden everyone's photos all look the same.

4. How do you keep your kids interested in having their photograph taken? I made a rule for myself that if the kids ever ask to not be photographed, I immediately just say "okay" and put the camera down. No fuss, no insisting, I just put the camera away like it's no big deal. The second you give them power by pleading or begging them, they will wield that power, ruthlessly. They don't know any better; they have no choice but to beat you down with stubbornness.

5. What advice would you give to those who are ready to hone their artistic eye in terms of photographing their children? To me, great photos of the kids means catching them deep in a moment. So my advice is to keep the camera close and ready, and try not to disrupt a moment. Always look for the little details that tell part of their story: If their shoelace is untied, leave it alone. Don't tidy them up for every single picture, and never, ever, say "smile."

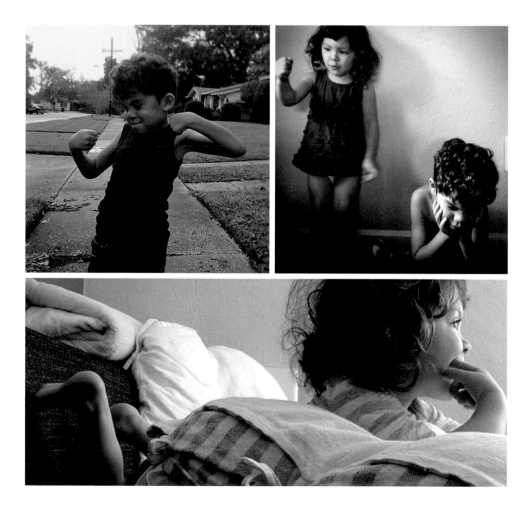

MIA MORENO

www.thesetenderhooks.com

Mia Moreno is an artist, photographer, and mother living and working in her hometown of El Paso, Texas. She has a BFA in drawing with a minor in painting from the University of Texas at El Paso. If she is not drawing, painting, sewing, or out on a photo-taking adventure, then she is probably watching *Little House on the Prairie* reruns with her daughter Isabella—her inspiration, muse, and sparkly little sunshine.

1. What do you enjoy most about photographing your family? Photographing my daughter gives me the opportunity to practice patience and understanding within our relationship. It also helps me deal with some of the inevitable challenges of raising a girl in a world that tends to focus on the external. I believe taking the time to create thoughtful portraits can help my daughter develop healthy self-esteem. I love having photographs that reflect the way I feel about being a mother. Someday, when Isabella has a family of her own, they will be able to enjoy our memories, too.

2. What is your favorite camera to shoot with and why? I love shooting with my Polaroid cameras best, particularly with my Polaroid SX-70. But my Pentax K1000 comes in a very close second. Polaroid cameras and instant films give me images filled with dreamy, soft atmospheres and beautiful, magical tones. My 35mm Pentax K1000 is a tough, reliable camera that allows me to take advantage of having full manual control over settings such as focus, shutter speed, and depth of field. I carry both with me most of the time.

3. How would you define your style of picture taking? Do you think it's important to cultivate a style or just to shoot? I think developing a style helps express mood, emotion, and atmosphere in a specific sense. Discovering what interests you most about creating an image can help communicate your ideas more effectively. I attempt to capture my daughter so that she appears introspective. Capturing the beauty of innocence is important to me. My goal is to record Isabella's personality, as well as her likeness.

4. How do you keep your daughter interested in having her photograph taken? Using props helps keep my daughter's attention and can serve as a diversion from the ingrained "smile at the camera" shot. Favorite toys and objects work well. A reward system (aka bribery) also helps. I also allow Isabella to photograph me. This gives me the opportunity to teach her about photography, takes the pressure of posing off her, and keeps the mood light.

5. What advice would you give to those who are ready to hone their artistic eye in terms of photographing their children? Try to compose shots in the viewfinder of your camera without thinking about having the ability to crop them later. Knowing some basic composition rules can also help in learning to see potentially effective shots. A fitting background is just as important as your subject. It's important to be aware of the cut-off points on a body in portraiture. For example, don't cut off a shot at the ankle, wrist, or knee. Try to frame shots above joints—above the elbow and above the knee.

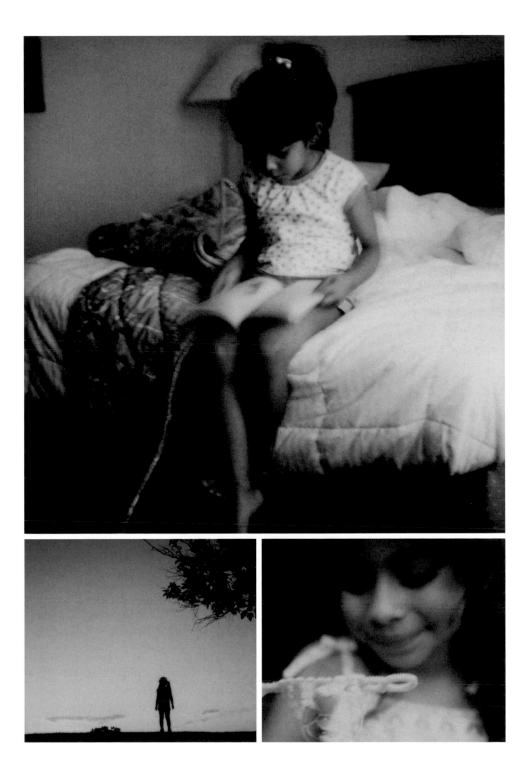

IRENE NAM

www.irenenamphotography.com

Irene Nam is a photographer and writer based in Paris, France, where she was born and raised. Her images have appeared in various print and online publications and on exhibit at the Fotofest Gallery in Houston and the Impossible Project Space in New York City. Irene works with nonprofit organizations to improve the quality of life, education, and future of children around the world. She is also a contributing author for ShutterSisters.com, a global community for women photographers and for *Expressive Photography: The Shutter Sisters' Guide to Shooting from the Heart* (published by Focal Press).

1. What do you enjoy most about photographing your family? The opportunity I'm given to extend a moment beyond the limits of time, distance, and memory, to hold onto that one moment and the emotions around it. Photographing my children also helps me validate the little things in life that I might otherwise tend to dismiss as trivial. It reminds me to live mindfully in the moment and cultivate a sense of wonder and love for simple things.

2. What is your favorite camera to shoot with and why? I mostly shoot with my Canon 5D (which I use with a 50mm lens) and my Polaroid SX-70, based on circumstances such as location and light. I truly enjoy the convenience and many possibilities that digital photography offers, but I have to admit that my love for Polaroid (and film photography in general), fully entrenched in the beauty of its texture, process, and imperfection, is expanding every day.

3. How would you define your style of picture taking? Do you think it's important to cultivate a style or just to shoot? To be honest, I don't know if I have a style. But I do have a vision that I believe is unique to who I am and that comes out in my images. So I would say it's important to cultivate a sense of authenticity, to do what brings you joy, to embrace your imperfections and let go of any preconceived notions about what is beautiful, and just shoot what you love.

4. How do you keep your kids interested in having their photograph taken?
I try not to make them pose. I also do not give them any sort of warning so that having their photo taken doesn't become something that bothers them or makes them self-conscious. I also share images with them as often as possible. Over the years, I've realized that this helps them understand what I do, but also allows them to experience the world and see themselves through my eyes.

5. What advice would you give to those who are ready to hone their artistic eye in terms of photographing their children? Have fun. Experiment. Don't aim for the perfect headshot. Look for the perfect moment instead, as fleeting as it might be. Learn the basics about lighting, composition, and depth of field. Although there's something daunting and intimidating about techniques in photography, developing your skills will enable you to create the images that you want. Listen to your inner voice. Silence your critical mind. Be patient. Actually, be very patient.

JENNA PARK

www.sweetfineday.com

Jenna Park is a freelance art director and designer and the co-owner of the Brooklyn-based bakery Whimsy & Spice, which she founded with her pastry chef husband in 2008. As an art director, she has designed websites for clients such as the Smithsonian Photography Initiative, Storm King Art Center, Aveeno, the Harvard Graduate School of Design, and Artspace. Jenna is an avid photographer; a blogger since 2001, she writes about life in New York, raising two little girls in the city, and juggling a family business.

1. What do you enjoy most about photographing your family? Knowing that we'll be able to look back on these photos five, ten, twenty years from now and have a record of history, not only of our family, but of the cities we lived in, the clothes we wore, the cars we drove, the way we furnished our homes. It's what I enjoy most about looking at my own childhood photos—an anthropological look at life in New York city during the '70s and '80s.

2. What is your favorite camera to shoot with and why? I shoot with the Canon 5D Mark II and tend to take that out with me most of the time, but that camera is a beast to carry! Like many people, I'm using my iPhone camera more and more to capture candid, everyday shots.

3. How would you define your style of picture taking? Do you think it's important to cultivate a style or just to shoot? I like to shoot what I see, to document and quietly observe. This is how I approach picture taking when people and places are my subjects. I adopt a similar approach to product photography for our bakery business, and I think our photos do have a style that has contributed a certain presence to the company's branding, but I'm less sure if any clear style exists for my other photographic work. I just keep shooting. I trust that eventually a style will emerge.

4. How do you keep your kids interested in having their photograph taken? As the girls get older, it gets tougher to coax natural expressions out of them. Many times they will pose or put on exaggerated smiles as they become more aware of the camera. My older daughter is also at an age where she is less willing to be photographed and will often hide from the camera. This is why I like to shoot candid moments, almost as if I'm not in the same room as they are, never interrupting them in play or in motion, but just documenting what is happening.

5. What advice would you give to those who are ready to hone their artistic eye in terms of photographing their children? While formal portraiture can be beautiful, I think the most interesting shots are those that are completely candid and of the moment. That is the beauty of photography after all—the ability to capture moments unseen by the eye. For me, these moments are often found when I'm photographing my two girls together. I might capture a look, a shared expression, or interesting body language between the two of them that tells a story.

I find that one of the best times to photograph children is when they're playing or engaged with an activity. They are not as self-conscious about the camera, and it's easy to move around and shoot from all angles. Sometimes I'll call to my girls to look up so I can get a shot where they are looking into the camera. It's spontaneous enough so there is little time for them to pose and put on one of their "camera faces"!

LYNN RUSSELL

www.satsumapress.com

Lynn Russell is the letterpress printer and designer for Satsuma Press. She works and makes her home in Corvallis, Oregon, with her husband Ben and their seven-year-old son, Liam. Liam has a rare neuromuscular disorder called Spinal Muscular Atrophy Type 2. He is, of course, much more than his diagnosis—charming, smart, mischievous. Many things are altogether different than what they ever could have imagined—sometimes heartbreaking, sometimes amazing, and sometimes both at the same time.

1. What do you enjoy most about photographing your family? I love capturing a look on Liam's face—delight, wonder, joy, daydreaming. Every parent will say this, but kids just grow up so fast—so it's important to me to be able to document these little pieces of our life, even though I am not very good at having my camera at the ready. My photographs tend to ebb and flow, which is okay with me, too.

2. What is your favorite camera to shoot with and why? I have three cameras: a Nikon D40, a Canon G10, and my iPhone. I bought the Canon because of its smaller size, but I actually tend to use the other two most often—the phone camera because I always have it with me, and the Nikon for most of my product shots and portraits. I just got a new lens for the Nikon with auto-focus, which—at least for me—is key when taking photos of kids.

3. How would you define your style of picture taking? Do you think it's important to cultivate a style or just to shoot? I don't like complicated, fussy images, so I like to think that I keep it simple—as much for photography as for my letterpress printing and design. It's important to cultivate a style, whatever that may be, that's consistent with your own aesthetic. Part of that, I think, lies in simply taking more photos so that you can distill your images down to what appeals to you most.

4. How do you keep your son interested in having his photograph taken? Ha! Liam is a pretty photogenic child, at least he was until the past year or so. Now he loves to make horrible faces at the camera for fun, so I try to sneak photos of him when he is otherwise occupied.

5. What advice would you give to those who are ready to hone their artistic eye in terms of photographing their children? I don't think any kid looks as good in a staged environment as in their natural one. Good, natural lighting without a flash—that's important to me. I don't like posed photos, so I try to find moments when Liam is immersed in something—by himself or with his papa or his friends. These are always the sweetest, most genuine photos.

RACHEL SALDAÑA

www.buttonsmagee.com

Rachel Saldaña is a photographer, writer, and blogger. Her work has been featured both online and in galleries including photographs featured in *Somerset Life* magazine. She also shot the photography for the watercolor book *Water, Paper, Paint* by Heather Smith-Jones. Rachel currently resides in Corpus Christi, Texas, with her husband and two daughters. She loves finding beauty in the everyday and can be found writing about her search for contentment on her blog, Buttons Magee.

1. What do you enjoy most about photographing your family? For me, the best part of photographing my own children is the comfort they feel around me. Being children of a photographer means getting accustomed to having a camera around constantly. They never even pay attention to me anymore, and I am able to capture moments that might normally be missed due to self-consciousness. I look back at photos from years past and really can see my girls' personalities on display.

2. What is your favorite camera to shoot with and why? The camera I pick up most often is my Pentax KM 35mm, a camera I've owned since high school. Film is my first love, and that camera feels like a part of me. I also have a Hasselblad 500c medium format film camera and an Olympus e-500 DSLR that are on heavy rotation.

3. How would you define your style of picture taking? Do you think it's important to cultivate a style or just to shoot? I would like to consider my style to be more of a natural photography. I never ask for a smile from my subject, preferring to go with whatever reaction they are giving me. The same goes for actual portrait sessions. I believe the more you shoot, the more you will begin to see a personal photographic style emerge. Take a lot of pictures and take them often. Before you know it, you will just have a way you go about shooting.

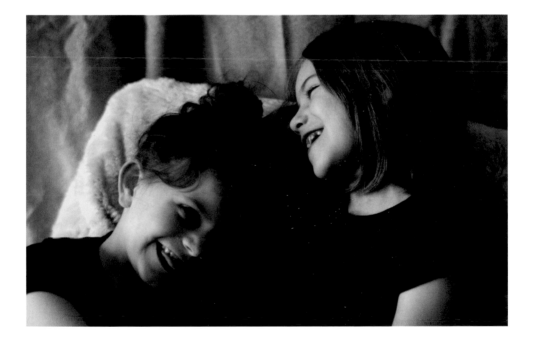

4. How do you keep your kids interested in having their photograph taken? I most often act as a shadow and just shoot them doing whatever it is they are already doing. They usually pay no attention to me. If I do want to have more of a portrait session, I try to include props of some kind or music. In addition, I will usually tell them that I am testing lighting or some such thing so they stop fixating on the lens. I also keep them occupied with conversation and joking so they stay interested.

5. What advice would you give to those who are ready to hone their artistic eye in terms of photographing their children? I would say to learn to look for the "after-shot." That is the photo right after a slightly more stiff moment. Maybe the kids are being silly making faces. Eventually, that silliness will turn into an actual moment of laughter and genuine smiles. Also, patience is key when it comes to children. Finally, I would say practice, practice, practice. The more photos you take, the better your eye will become!

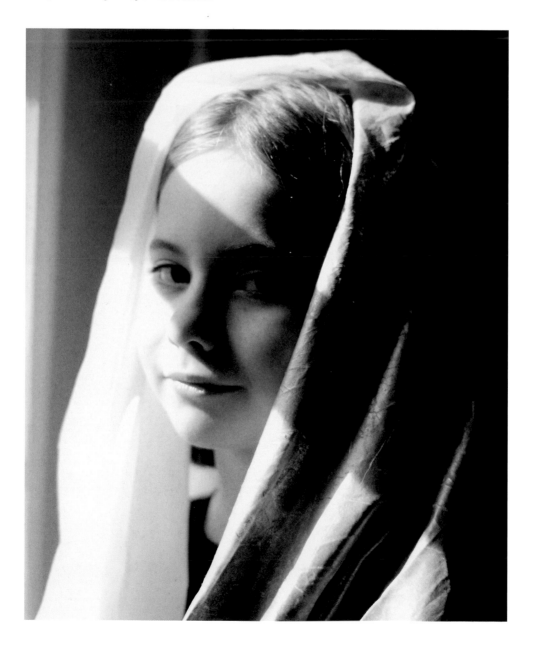

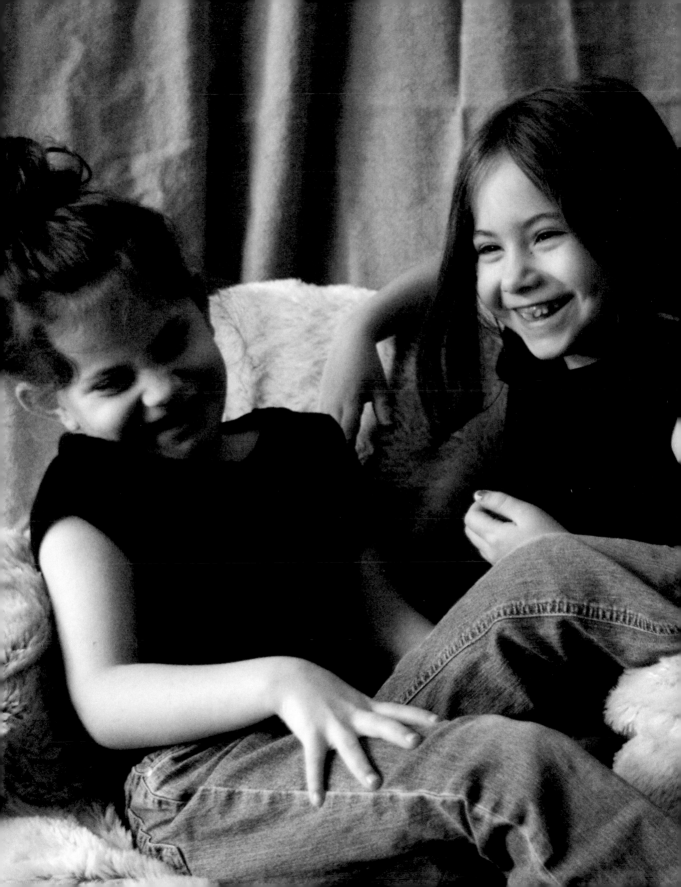

CH. 7

WHAT'S NEXT?

You've now taken the time to shoot manually, and you are rewarded with photographs that are beautifully composed, well lit, and a happy reflection of your little one's unique personality. But maybe, that last shot was a little too dark, maybe the background in the previous shot is too bright? Do you leave all these photographs on your hard drive? What in the world do you do next? In this chapter we will review a few simple edits you can make to your photographs and make recommendations on how to print, store, and share your photographs as well.

EDITING

Editing, or what's commonly referred to in photography as *post-processing* is, in simplest terms, ensuring your photo files are print ready. Photographers have varying views on this. Some shoot with the intention of heavy post-process later. When you shoot like this, you're not looking for perfection in-camera, but in your editing software. There is absolutely nothing wrong with this work structure, but I'm inclined to think of those people not as photographers, but as digital artists. Some strikingly gorgeous post-processing applications can transform the most mundane photograph into a work of art. Some use color and texture filters to replicate vintage cameras. Some have strong lighting and contrast applications to make it seem that the photograph was shot with a commercial camera. When the process of specific edits and filters has been saved to use on multiple photographs, these saved steps are called "actions." If you are interested in applying these types of actions to your photographs, simply google "photoshop actions" and you will find hundreds of free and for-purchase.

I'm of the school that likes to get it right in-camera. If I want the image to look like it's shot with a vintage camera, I will shoot film in a vintage camera. The choice is personal and is really determined by where you are more comfortable spending your time, behind a camera or a computer. Though I shoot for perfection, it is rarely 100 percent realized. In most cases, I will have to at least boost the contrast or heal a stray mark. The most commonly used tool for editing photographs is Adobe Photoshop. If you do not have it, I suggest starting with Adobe Photoshop Elements, the baby brother to the traditional software. The type of editing we discuss in this chapter can be achieved with Photoshop Elements. You'll find more detailed information in Adobe's own publications and tutorials on the Internet, but we will quickly look at the most commonly used applications in the software. You will find most of what you need in your toolbar and top menu.

» Cropping Tool: This tool allows you to crop your image. For example, if you photograph your child and want to remove something from the background or perhaps create a tighter facial shot, this is the tool you'll use.

» Spot Healing Brush Tool: This tool, whose size you can change in the control panel, allows you to clean up stray marks in your photograph.

» Blur and Sharpen Tools: This tool allows you to blur sections of your photograph or sharpen them. Avoid using the sharpen tool too much, as it tends to create "noise" to achieve its task. The blur can come in especially handy when you are shooting with a point and shoot camera. As we discussed in the first chapter, while you are able to achieve a natural blur by shooting at a lower f-stop on a DSLR, you cannot achieve this look on a point and shoot. By carefully blurring the background in Photoshop, you can create that look post-process. Be mindful of the strength of the blur tool (you can control this in its menu); you want the impression to look as natural as possible.

» Dodge Tool: The dodge tool is used to lighten or highlight areas of your photograph. As with the spot heal brush, you can control the size of the tool for the area you are working on.

» Burn Tool: The burn tool darkens areas of your photograph and is controlled the same way as the dodge tool.

In the top menu of the software, you will also find helpful tools to aid you. Start under "Image," scroll down to "Adjustments," and play with both the curves tool and the color balance and brightness/contrast tools; all will help you fix any lighting issues you may have had when shooting.

As an illustration of how subtle editing can be, look at the original photograph in figure 14, and the edited shot in figure 15. Can you tell what small changes were made?

fig. 14 fig. 15

1. I cropped the photograph so my daughter was tighter within the frame.

2. I brightened the image overall just a little with the curves tool.

3. I adjusted the color balancing with additions of cyan and blue.

4. I darkened the background with the burn tool.

5. I erased a few stray marks in the background with the spot heal brush.

6. And last, I used the dodge tool to brighten her hair, flower, and arm.

Entire tomes are dedicated to this software, and I encourage you to start simply. You will probably find that just these few steps are enough to add that extra punch to your photograph. If you want to delve deeper, check the Resource section of this book for some recommendations on what books are most helpful in explaining how to use Photoshop.

STORING AND PRINTING

If you are like a lot of digital photographers, in time you may find yourself with thousands of photographs and really nothing tangible to show for your efforts. One of the greatest differences between film and digital photography is how photographs are stored. We no longer have negatives to file and copious numbers of prints to sift through. Now our hard drives are strained under the weight of full-size, unedited files.

I have a rule for myself that as soon as I've shot something, whether personal or professional, I sit down and pull everything I plan to edit into a single folder on my computer. All unedited files will then find their way to an external back-up hard drive. But I do save them. I have found myself on many occasions going back through files to find images I missed, and I often see an old photograph with a new eye. Some shots are obviously problematic; they are blown out or overexposed, way too dark, too blurry, maybe a really unflattering expression was captured—delete these, there is no reason to let these files take up room on your hard drive.

You can also choose to store your photographs online. Many Internet providers and online vendors offer storage space in what's called "the cloud"—think of it as a virtual filing cabinet. Most of these vendors provide ample space for a low monthly fee.

Also! Check and then double check that your files are backed up on your computer and external hard drive before formatting your memory card (deleting data), because once you have, the images are gone forever!

On your computer, create a filing system that makes sense to you. Some people like to file and store photographs by date, maybe one folder for 2013, then separate folders for each month. You could even segregate your photographs further by child's name or by event within those months. Whatever system you create, it needs to make sense to you and be easy to maintain. I also create folders under specific events labeled "Unedited," "To Edit," and "Edited," keeping all the

photographs in that group together. Once I have had the chance to pull everything I want to edit into "To Edit," I then move the "Unedited" to my external back-up drive.

And don't forget to print! The advances in technology have made high-quality home printing devices affordable, and they give you the luxury of printing on demand. Paper is important. You will find that better quality paper will give you results that mirror what you see on your computer screen. There is also a list of exceptional printers in the back of this book if you would rather out-source. When using a printing lab, do remember the following:

» Save files at at least 300dpi (dots per inch) and the actual size you want to print. You can print smaller, but will have difficulty printing larger if the file does not reflect the correct dimensions.

» Save your files in RGB color space, as that is what most printers require for correct color calibration.

» Most printers will ask for jpg files. These files tend to be smaller than tiff or psd files. However, for the longevity and health of your image files, save edited images as tiff or psd as well, because they retain more image information with use.

» Some printers may ask you to calibrate your monitor to ensure the colors are correct. You can easily find instructions online to walk you through this process for your specific computer.

» Be sure NOT to select the option to have your files color-corrected. Often this results in strange color shifts that you are not expecting.

SOCIAL MEDIA

The most popular way to share photographs now is on the Internet. There are many platforms for you to do this: Facebook, Twitter, Flickr, even your own blog. The advent of social media allows you to share images literally with the push of a button. It offers a wonderful way to keep friends and relatives up to date on your little one's progress and your own as a photographer. Flickr and other online photography communities are also wonderful places to find like-minded photographers, ask

questions, and learn to shoot better. You will find a list of the most popular photo communities in the Resources section.

You can also use these resources as learning tools without sharing your own work. Social media is a brilliant way to share our lives, but you have to feel comfortable with the boundaries, and in social media, there are few. Sadly, the reality of the situation is that when you put your child's photograph online, even if you've protected it, it could end up anywhere. Be aware of this when you decide which types of photographs you share online, and do take precautions to prevent others from downloading your work without your permission. Many online sharing sites, such as Flickr, have privacy options that allow you to block those you've not approved from seeing your photographs.

PROJECTS

While the potential is nearly limitless, here are a few simple project ideas to take your photographs one step further.

A Year in the Life Book: I LOVE books. And really love photography books. Every year, I create a book of photographs for the girls' grandparents. Not only is it a wonderful gift idea, but I can't tell you how much fun I have going through the photographs and reliving our last year. It's almost therapeutic, and is an acute reminder of how blessed we are. There are so many approaches to putting a book like this together, here are a few ideas to get you started:

» The Resource section of this book lists some of the companies that can print your photo books. Most have easy-to-use software that you download to your computer. You then select a template for your book design, upload your images, and place your order, and you have a book. Yes, it's really that simple. If you are Photoshop savvy, you can layer text over some of your images to introduce new sections.

» Consider how you want to lay your book out. Chronologically makes sense, but there are many ways to do it—by major events that year, by child, and so on. Play with a few options until it makes sense to you and will to others as well.

» We talked about the fact that capturing your children's lives is more than just their beautiful little faces. Scan or take photographs of drawings or notes and include them in the book as well.

» Make a mini handheld book out of your camera phone shots.

If you are feeling really creative, you can make the book by hand. There are some great online tutorials for hand binding books, and your children can help decorate the pages. Use prints of photographs from your home printer or a professional printing lab.

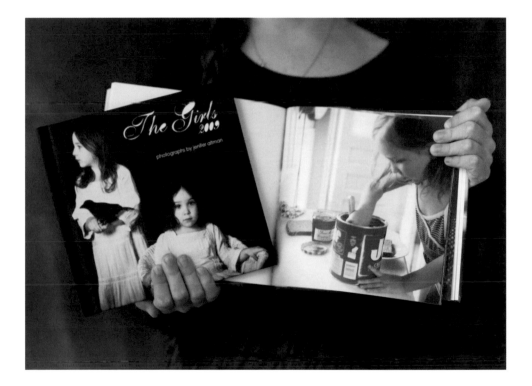

A BLOG

We are a blogging family. I created Nectar & Light in 2007 to document our "sweet life" through Polaroid photographs. While other types of photography trickle onto the site now and then, this blog allows me to keep focused on the goal of continuing to shoot instant film. My two eldest daughters both have blogs as well. Adie Fey takes instant images for her blog, Adie Loves Polly, and I take photographs of the creative ensembles that Ayla Eve creates for herself on All About Eve.

If you are interested in starting a photography blog, think about what parts of your children's lives and your lives together you want to share with others. Find focus and shoot with your heart, and you cannot go wrong. Although blog readers love well-shot photos and blogs with beautiful photography tend to really stand out, readers love to well . . . read. Do not be afraid of writing. Embrace it. You do not have to be poetic, but you do need to be authentic. Keep in mind, however, how accessible what you write is. Share only what you are comfortable sharing.

If your child is old enough to take an interest, involving them can be a wonderful experience for you both. Adie, now nine, wanted to start shooting Polaroids with me when she was four. So I found her an older camera (she named it Polly) and bought her some film. When Polaroid stopped making the film, I moved on to film created by The Impossible Project and Adie moved on to a Fuji Instax (that she, of course, calls Polly). As Adie's little sister Ayla got older, she wanted a blog, too. An idea formed naturally when Ayla began dressing herself. She has a shockingly mature eye for color and proportion and was coming up with the most wonderful outfits, and I started to photograph them. I don't force my girls to blog; I want to keep it fun for them. When they've decided they don't want to do it anymore, we won't.

If you want to start a photography blog centered around your child, focus on their passions and do not set unattainable goals for yourself (like posting every day), as you are at the mercy of their always flitting interests. Keep it fun, light, and fresh, and you might be surprised at what you gain in return. Check out Blogger, Typepad, and Wordpress for easy-to-use blogging platforms.

SILHOUETTES

This is a fun and easy project and one of the most amazing gifts you can give grandparents—they will LOVE it. Traditionally, silhouettes were paper cutouts, and the craft is still practiced today. The subject would sit behind a lit screen, and the artist would trace the outline of their shape on paper, and then carefully cut out the shape, preserving every little curl. It is a fascinating art form. This project cheats a bit, okay a lot, but you end up with a beautiful finished project.

Start by photographing your child. Position them in front of a white or very light background, turned to the side so that you view their profile through your viewfinder. Ensure that the profile is strong. If the child turns just a touch toward or away from you, you are at risk of losing their nose! Once you have the photograph, upload it into Photoshop and convert it to black and white. (Note: Do not change the image size at this point, as you will then be restricted to that print size when you have finished.) Figure 16 shows the original photograph.

Add a bit of contrast so that the edges of your child's form become more prominent. Then, using the burn tool, darken the shape of the child, paying particular attention to all of the edges. (See figure 17.)

Now you can do one of two things. Figure 18 shows the contrast boosted to a full 100 percent.

Figure 19 used the stamp tool (under the Filter menu > select Sketch > then Stamp).

Finally, use the brush tool in the toolbar to fill in any white spaces with black. You can see in figure 20 that I filled in a part of her bun as well.

fig. 16

fig. 17

fig. 18

fig. 19

Flatten the file and save it at 300dpi and as large as you want to print! You can also have the image silkscreened on a pillow or canvas tote bag as a fun alternative.

fig. 20

MORE IDEAS

» Yes 8" x 10" and 11" x 14" are respectable print sizes—but go big! Printers can print your photographs quite large (we have a 40" x 60" print in our home), and they make quite a wall statement.

» Print photos on copy paper at home to create homemade gift wrap or gift tags.

» Remember the sequencing shooting we talked about in chapter three? You can string those shots together in a program like iMovie to create a short stop-motion movie. There is a great tutorial at http://content.photojojo.com/tutorials/stop-motion-digital-camera/.

» If your child shows interest in photography (or simply your camera!), spend a few dollars for a disposable film camera and let them shoot their heart out. You may be surprised with the results.

» Your photos don't always need to be framed. Try printing some of your favorites and arranging them directly on your wall in a fun shape like a heart or arrow.

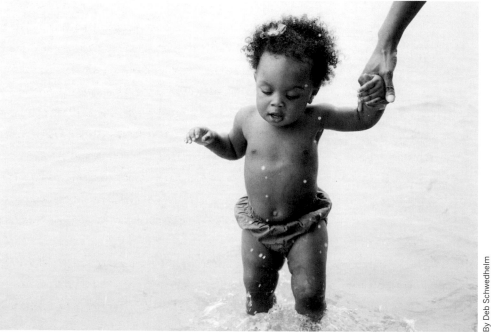

By Deb Schwedhelm

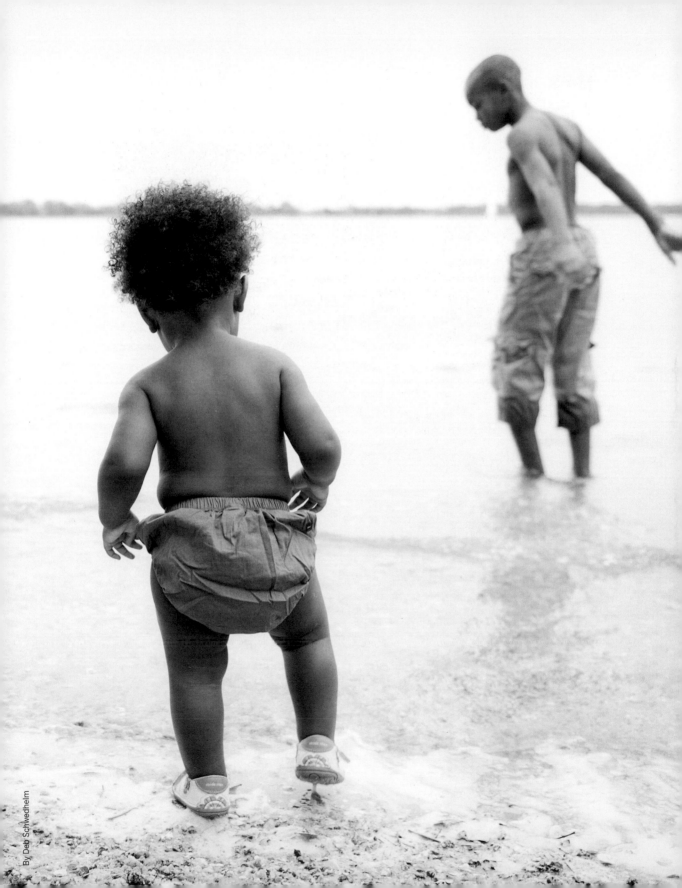

RESOURCES

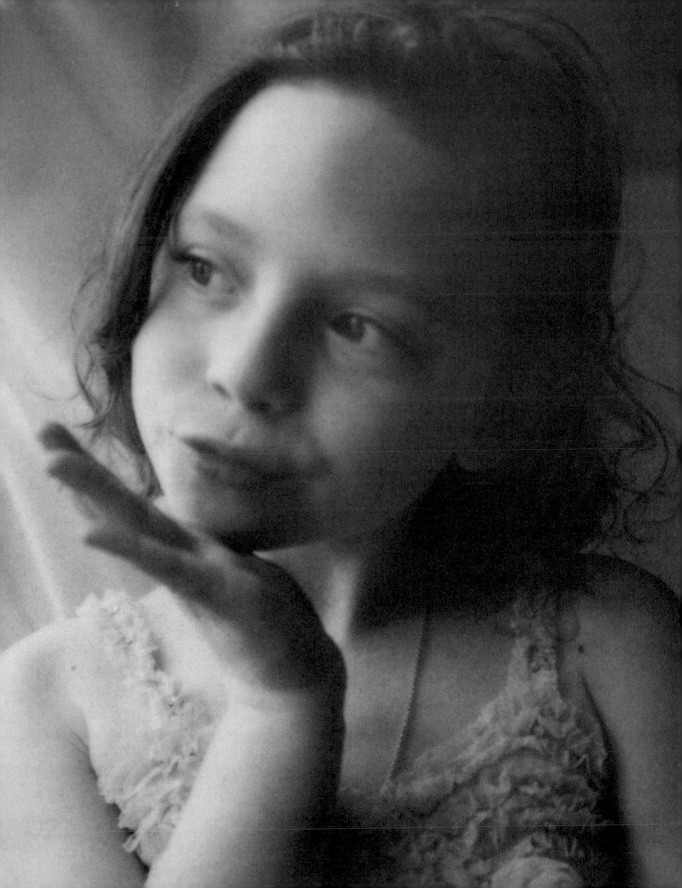

RESOURCES

PHOTOGRAPHY BOOKS & MAGAZINES

Here is a list of books that will give you further insight into the art of photography and advanced techniques and examples by inspiring photographers.

A World History of Photography by Naomi Rosenblum

Adobe Photoshop CS5 for Photographers: The Ultimate Workshop by Martin Evening and Jeff Schewe

Expressive Photography: The Shutter Sisters' Guide to Shooting from the Heart by the Shutter Sisters

FACES: Photography and the Art of Portraiture by Steven Biver and Paul Fuqua

Fantastic Plastic Camera: Tips and Tricks for 40 Toy Cameras by Kevin Meredith

Hot Shots: Tips and Tricks for Taking Better Pictures by Kevin Meredith

In Focus: National Geographic Greatest Portraits by the National Geographic Society

Instant Love: How to Make Magic and Memories with Polaroids by Jen Altman, Susannah Conway, and Amanda Gilligan

National Geographic: The Photographs (National Geographic Collectors Series) by Leah Bendavid-Val

Photojojo!: Insanely Great Photo Projects and DIY Ideas by Amit Gupta and Kelly Jensen

Pinhole Cameras: A DIY Guide by Chris Keeney

Portraits by Steve McCurry

The Best Camera Is the One That's With You: iPhone Photography by Chase Jarvis

The Elements of Photography: Understanding and Creating Sophisticated Images by Angela Faris Belt

The New York Times Magazine Photographs edited by Kathy Ryan

The Photographer's Vision Understanding and Appreciating Great Photography by Michael Freeman

The Photography Book by Ian Jeffrey

Vivian Maier: Street Photographer by Vivian Maier and John Maloof

Ways of Seeing by John Berger

Your Baby in Pictures: The New Parents' Guide to Photographing Your Baby's First Year by Me Ra Koh

A list of magazines with fresh and forward children's photography. Use these as inspiration to create your own small shoots for your children.

Babiekins:
www.babiekinsmag.com

Dolittle:
www.doolittle.fr

La Petite:
www.lapetitemag.com

Little Fashion Gallery:
www.littlefashiongallery.com/fr/lfs-press/magazine

Lucky Kids:
www.luckymag.com/kids

Luna:
www.lunamag.de

Milk:
www.milkmagazine.net

Papier Mache:
www.papier-mache.com.au

Small Magazine:
www.smallmagazine.net

PHOTOGRAPHY SHARING SITES

Websites and online communities to share photographs and grow as a photographer; many also include on-demand printing services.

DeviantART:
www.deviantart.com

Flickr:
www.flickr.com

Fotki:
www.fotki.com

Fotolog:
www.fotolog.com

ImageShack:
www.imageshack.us

JPG Magazine:
www.jpgmag.com

Kodak Gallery:
www.kodakgallery.com

Photobucket:
www.photobucket.com

Picasa:
www.picasa.google.com

Polaroid:
www.polanoid.net

Shutterfly:
www.shutterfly.com

Webshots:
www.webshots.com

BLOGGING SERVICES

Blogger:
www.blogger.com

Squarespace:
www.squarespace.com

Tumblr:
www.tumblr.com

TypePad:
www.typepad.com

WordPress:
www.wordpress.com

SHOPS

Great resources for buying new and used and renting camera equipment, film, and accessories.

Adorama:
www.adorama.com

B&H: Photo-Video-Pro Audio:
www.bhphotovideo.com

Borrow Lenses:
www.borrowlenses.com

Calumet:
www.calumetphoto.com

Ebay:
www.ebay.com/electronics/camera-photo

The Impossible Project:
www.the-impossible-project.com

KEH Camera:
www.keh.com

Lens Pro:
www.lensprotogo.com

Lens Rentals:
www.lensrentals.com

Midwest Photo Exchange:
www.mpex.com

Ritz Camera:
www.ritzcamera.com

Samy's Camera:
www.samys.com

Wolf Camera:
www.wolfcamera.com

PHOTOGRAPHERS

A list of noted professional children photographers to inspire you.

Jenifer Altman:
www.jeniferaltman.com

Dani Brubaker:
www.danibrubaker.com

Delphine Chanet:
www.delphinechanet.com

Rebecca Drobis:
www.rebeccadrobis.com

Pamela Klaffke:
www.pamelaklaffke.com

Anna Moller:
www.annamoller.net

Emily Nathan:
www.emilynathan.com

Melanie Rodriguez:
www.melanierodriguez.eu

Emily Ulmer:
www.emilyulmer.com

Steven Visneau:
www.swvphoto.com

Sarah Wert:
www.modernkidsphoto.com

CONTRIBUTORS

Pages 98–101:
Jördis Anderson and Mathias Meyer:
www.beagoodgirl.net and
www.holgarific.net

Pages 80, 83–84:
Jennifer Causey:
www.jennifercausey.com

Pages 102–104:
Melissa Frantz:
www.allbuttonedup.typepad.com

Pages 105–109:
Carissa Gallo:
www.carissagallo.com

Page 65:
Amy Haney:
www.amyhaney.typepad.com/

Pages 109–111:
Hannah Huffman:
www.flickr.com/photos/haeshu/

Pages 112–114:
Ryan Marshall:
www.pacingthepanicroom.com

Pages 115–117:
Mia Moreno:
www.thesetenderhooks.com

Pags 8, 49, 75, 118–120:
Irene Nam:
www.irenenamphotography.com

Pages 121–123:
Jenna Park:
www.sweetfineday.com

Pags 124–126:
Lynn Russell:
www.satsumapress.com

Pages 126–129:
Rachel Saldaña:
www.buttonsmagee.com

Pages 50, 67, 71, 144–145:
Deb Schwedhelm:
www.debsphotographs.com

Pages 34, 69:
Jennifer Way:
www.jenniferwayphotography.com

Pages 9, 85, 94:
Sarah Wert:
www.modernkidsphoto.com

INDEX